IMAGES
*of America*

# LAKE PLEASANT

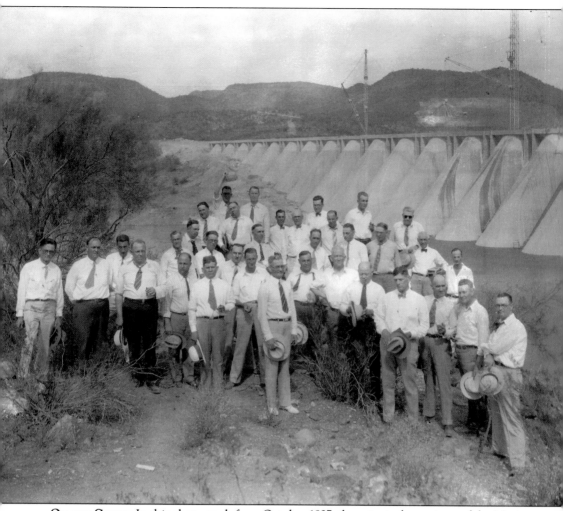

**ON THE COVER:** In this photograph from October 1927, the principal associates of the Maricopa Water District stand proudly in front of their work—the Pleasant Dam, which would create Lake Pleasant. Both were named after the project's chief engineer, Carl Pleasant, who is standing fourth from the right in the first row. The dam would later be renamed the Waddell Dam. Though actual construction took only about two years, the quest to make Lake Pleasant a reality was a 40-year odyssey. Missing from the photograph is the man who shepherded the project for most of that time, only to die on the eve of construction: William H. Beardsley. Death would also claim Carl Pleasant before he could see his work fulfill its purpose. (Courtesy of Salt River Project.)

IMAGES
*of America*

# LAKE PLEASANT

Gerard Giordano

ARCADIA
PUBLISHING

Published by Arcadia Publishing
Charleston, South Carolina

Printed in the United States of America

Library of Congress Control Number: 2009923818

For all general information contact Arcadia Publishing at:
Telephone 843-853-2070
Fax 843-853-0044
E-mail sales@arcadiapublishing.com
For customer service and orders:
Toll-Free 1-888-313-2665

Visit us on the Internet at www.arcadiapublishing.com

*To Rose, who said I should, and to Lisa, who makes all things possible*

# CONTENTS

# ACKNOWLEDGMENTS

When teaching history, I always differentiate between the past itself and the records left from the past that we interpret as history. Our accurate and complete recollection of time is only as good as the records we have left and how well people preserve them. I was truly blessed to have so many people who are good stewards of our heritage.

I owe a great debt of gratitude to the U.S. Bureau of Reclamation and in particular to two individuals. Archaeologist Jon S. Czaplicki took me under his wing, ushering me to a wealth of information and images related to Lake Pleasant. Moreover, he introduced me to many of the other good people who made this book possible. The other is engineer Jeffery Riley, who gave me a crash course on civil engineering. He patiently turned the documents I was puzzling over right-side up, translating the technical into the tangible. I would also like to thank Margaret Carlberg and Bryan Lausten from the Phoenix office and Karen Cowan of the Boulder City office.

I am indebted to the Maricopa County Parks and Recreation Department. Very special thanks to Ranger Terry "Iron Man" Gerber, who showed me firsthand the wonders of Lake Pleasant Regional Park. Thanks also to Darci Kinsman and Dawna L. Taylor.

Special thanks go to the Maricopa Water District for taking time from the busy work of watering the desert to open their files to me, especially Glen Vortherms, Koko Kvistad, Diana Rojas, and Stephanie Tate. A special thank you as well to Bob Beardsley, great-grandson of William H. Beardsley, for adding the last few pieces to the puzzle.

I also would like to recognize the Phoenix Public Library, especially Kathleen Garcia, friend and fellow author, for showing me how it's done; Archaeological Consulting Services—Marjorie Green, Brad Dilli, and Theresa Pinta; the Central Arizona Project—Crystal Thompson and Philip Fortnam; Pueblo Grande Museum—Todd Bostwick and Larry Warner; and the Salt River Project—Catherine May. Finally, thanks to Bruce Gill, audiovisual ace and good friend, for his expert technical assistance with digital imagery.

# INTRODUCTION

Terraforming, though not in the dictionary, means "earth shaping." It was coined in the 1940s by Jack Williamson and used by science fiction writers ever since. Among the best known terraforming stories is the Mars trilogy by Kim Stanley Robinson. Bold adventurers seed the Red Planet—reengineer its atmosphere and release liquid water, rendering it more habitable—for better or worse. However, as is often the case, one need not look to science fiction for such drama. It has already taken place. Like the Robinson stories, it spans hundreds of years, involves radical changes to the environment, and affects millions of people. This true story unfolds not on some distant world but here, on Earth, in the deserts of the American Southwest.

One of mankind's early terraforming efforts began in Central Arizona. Once, the Gila River, including the Salt River and the Agua Fria, carried more water to the sea via the Colorado River than Texas's famed Rio Grande. Now home to one of the largest population centers in the United States, it is all but impossible for the people living in the metropolitan Phoenix area to visualize the sight that greeted the Hohokam when they entered the area around the time of Christ. Instead of the mostly dry riverbed bisecting today's metropolitan area, a ribbon of green cut through the desert wilderness. By AD 300, they began establishing elaborate irrigation systems. About AD 700, they expanded up the Agua Fria River, developing settlements there. By the time Columbus sailed, the Hohokam were gone. Yet they left their mark upon the environment. Their diversion of local rivers is estimated to have enabled as many as 50,000 people to inhabit the otherwise inhospitable Arizona desert. Of that number, archaeologists think that as many as 3,000 may have lived along the Agua Fria.

The exact origin of the river's name, Agua Fria (Spanish for "cool water"), is unknown. It stretches more than 120 miles from Yavapai County near Prescott, south through the Black Canyon, into Maricopa County, and into the Gila River west of Phoenix. Western man first encountered the Gila and Salt River Valleys when the area was a part of New Spain. Eusebio Kino explored the Gila in 1695. It became a part of Mexico in 1821. With the 1848 Mexican Cession, it became U.S. territory, with the Gila as the southern boundary of the United States. The Gadsden Purchase of 1853 pushed that border farther south. During this time, the Yavapai hunted and gathered along the Agua Fria, leaving it largely undeveloped, while the ruins of the Hohokam crumbled slowly into dust. However, two developments would begin to change things.

Gold was discovered in Prescott in 1863 and around Wickenburg, northwest of Phoenix, a year later. This ushered in a period of active mining, particularly around the Bradshaw Mountains, where water from the Agua Fria was needed for operations. In 1866, pioneer John Y. T. Smith began harvesting wild grass along the Salt River to sell as hay to the army and local miners. The next year, Jack Swilling formed the Swilling Irrigating and Canal Company, the purpose of which was to rehabilitate the Hohokam canal system and deliver water, the missing ingredient, to the valley's good soil and long growing season. By 1900, hundreds of miles of canals and laterals irrigated over 100,000 acres along the Salt River. Some development occurred along the Agua

Fria, but it was mostly limited to supporting mining actives. Perhaps the most significant was the Humbug Creek Placer Mining Company. In 1890, they built a dam, canal, and tunnels to support mining along Humbug Creek (a tributary of the Agua Fria)—the most ambitious development since the Hohokam. As mines in the Agua Fria watershed began to play out, developers looked to the river as a potential source for developing agriculture in the western portions of the Salt River Valley.

The Agua Fria Water and Land Company organized in 1888. By 1892, plans for several dams and canals along the Agua Fria were put forth. The first site chosen was Frog Tanks, a stage stop along the route to Castle Hot Springs Resort about 35 miles northwest of Phoenix. That same year, the company secured water claims and contracted with George Beardsley's Agua Fria Construction Company to bring the plans into existence. Joining him as general manager was his brother, William Henry Beardsley of Ohio, an enthusiastic supporter of the project. William also joined the board of Agua Fria Water and Land, becoming president by 1895. In 1894, plans called for two storage reservoirs, a diversion dam, and some 50 miles of canals. Despite an ongoing economic depression, the Beardsleys managed to establish Camp Dyer (named after a surveyor in Beardsley's employ) and work began on the Camp Dyer Diversion Dam and the Beardsley Canal.

By 1895, William Beardsley had persevered through cost overruns, difficult construction, and the death of brother and partner George. By October, they had blasted, scraped, tunneled, and erected the Camp Dyer Diversion Dam to a height of over 30 feet. The Beardsley Canal was extended 4 hard miles and was ready to be linked to the dam at the proper height. October also saw Beardsley's hopes for completion of the first phase of the project carried away by a flood, along with the west side of the dam. Gone too was the money. Beardsley was compelled to bring the project to a halt—a temporary one, he maintained. Robert "Jerry" Jones was appointed watchman at the site until things could begin anew. Jones would have a very, very long tenure.

Unable to raise money and facing legal complaints from unpaid subcontractors, both the Agua Fria Water and Land and Agua Fria Construction Companies went bankrupt in 1896. Assets were awarded to the plaintiffs and sold. This might have been the end of the story but for the fact that the buyers of the dam, canal, and the Frog Tanks dam site happened to be associates of Beardsley's from Ohio, who promptly deeded the assets to him. Beardsley was again in control of the project, albeit in limbo. In the years that followed, he tried, with little success, to restart the project.

The year 1902 was both a blessing and curse for Beardsley. The federal government finally surveyed the Agua Fria. Secretary of the Interior Ethan Allen Hitchcock granted the Water and Land Company official easements for the project. Also, Congress passed the Newlands Reclamation Act, which allowed funding of irrigation projects in the West. Beardsley, however, sought to construct his project with private funds. The part of the act that affected him was a provision authorizing the Interior Department to withdraw public lands from sale in order to prevent wild land speculation. Unfortunately, this included the land that would receive the benefit of irrigation from Beardsley's Dam. The withdrawal left him with no lands to irrigate. In 1903, he managed to dodge a bullet. Under the Newlands Act, the Salt River Project organized, setting their service area boundary up to the Agua Fria's east bank. The Water and Land Company service area was west of there. A petition was made to the Department of the Interior to allow sale of the lands in question.

The matter was referred to the recently organized Reclamation Service under Dir. Frederick H. Newell. A feasibility study for the Agua Fria project was conducted. Surprisingly, despite a report indicating the project was both sound and achievable, Director Newell dragged his feet, requesting additional data—data not required of the Salt River Project's proposed Tonto (Roosevelt) Dam project. So began a protracted period of delays on the public lands withdrawal issue as a result of the tendency of the director to be wary of any perceived competition with the Salt River Project. Beardsley had to pursue more creative solutions to the problem.

Under the Indian Appropriations Act of 1904, privately held right-of-way lands, such as those owned by railroads, could be exchanged in equal acres and value for surveyed public lands, such as the lands withdrawn under the Newlands Act. Beardsley approached the Santa Fe Railroad,

suggesting they conduct just such an exchange of acreage it held in Northern Arizona for the public lands in the Agua Fria Water and Land service area. The benefit to the Santa Fe was not only the sale of land to the Agua Fria Water and Land Company, but the profit gained by transporting agricultural products to market from the newly irrigated acres. By owning the service area, Beardsley would gain real estate that would make the Frog Tanks project feasible again and could be used as collateral in securing financing to complete construction. The two parties reached an agreement in 1908. All that was required was the approval of the Department of the Interior. Secretary James Garfield, who succeeded Secretary Hitchcock, would not sign. The lands were determined not to have met the equal value requirement. The Santa Fe disputed the findings. They argued that since the lands in question were not required by the Salt River Project, the government should not inhibit private enterprise. Director Newell maintained that the government should not be forced to imply approval of a risky venture by opening affected lands to the public.

Finally, in 1909, Beardsley got the decision he wanted: Secretary Garfield rescinded the withdrawal order of his predecessor. The decision was a double-edged sword. It stipulated that developers needed to wait a month before filing for the land in the Water and Land Company service area. Beardsley and the Santa Fe would have to wait, allowing speculators the opportunity to file for the land. In lieu of this, Director Newell maintained that additional data requested for the feasibility study completed in 1903 was still required. To make matters worse, the General Land Office refused to accept the Santa Fe's exchange offer of 50,000 acres despite being among the first to file at the end of the 30-day wait. The railroad protested to the Secretary of the Interior, now Richard A. Ballinger, only to be accused of trying to take advantage of the Department by offering an exchange of land of inferior value. The Department also noted it would consider an offer involving an exchange of land of greater value. With political support solicited by Beardsley and the Santa Fe from Congress, the territorial governor, and the Phoenix business community, the exchange was made and 39,000 acres became Santa Fe property in 1910. They sold to Beardsley for $2.50 an acre in 1914. Beardsley, strapped for cash as ever, arranged to pay the railroad over time, finally doing so in 1920.

With the outbreak of World War I in 1914, cotton was in demand. Goodyear Tire and Rubber Company purchased 6,000 acres from Beardsley at $20 an acre. While all of this was occurring, a mining company, the Maricopa Development Company, filed litigation disputing the Agua Fria Land and Water Company's rights along the Agua Fria. Finally, by 1918, the Interior Department had granted all easements and permissions necessary for construction, all litigation had been fended off, and Beardsley had turned down several offers to buy the entire project. He would see it through to the end.

In 1919, he moved ahead with construction, hiring Carl Pleasant of Tulsa, Oklahoma, as chief engineer and Pekham and James to design the storage dam. A multiple-arch design was selected because of its strength and economy to build. The company changed its name to Beardsley–Agua Fria Water Conservation District in 1925, then to Maricopa County Municipal Water Conservation District Number One, also known as the Maricopa Water District (MWD). On December 15, 1925, William Beardsley died five days before Carl Pleasant signed a construction contract. His son, Robert Beardsley, took his place.

Renamed the Carl Pleasant Dam in 1926 and then the Waddell Dam in 1964, the Frog Tanks project was unique among other reclamation projects in that it was financed by private investment. The MWD undertook a bond issue to raise the estimated $3.325 million needed for construction. Brandon, Gordon, and Waddell of New York acquired the entire issue. Donald Ware Waddell relocated to Phoenix to oversee the project and established Waddell Ranch within the project service area. Meanwhile, several camps were located along Agua Fria, including a renewed Camp Dyer. Camp Pleasant was the largest, housing around 1,000 workers including some families. Work began in 1926 and had to be complete by the end of 1927. This included repairing and completing the Camp Dyer Diversion Dam, extending the Beardsley Canal another 28 miles, incorporating laterals into the irrigation system, constructing a flume over the Agua Fria, and constructing

the world's tallest multiple-arch dam. While this daunting task was being undertaken, the MWD was forced to fight another lawsuit by the Southwest Cotton Company over groundwater rights. As construction neared completion, cracks had formed on the dam buttresses. This sparked a firestorm over the dam's safety that, combined with the suit, threatened the project yet again.

Though engineers couldn't agree whether the cracks posed a real threat, the state nevertheless imposed limitations on water storage behind the dam. This left the MWD without a way to irrigate their service area. Along with an unfavorable ruling in the Southwest Cotton case, the fledgling reclamation project plunged into bankruptcy a second time. In 1930, two more calamities threatened to end the project: Chief engineer Carl Pleasant died unexpectedly, and a prolonged drought ensued. Even after the MWD successfully appealed the Southwest Cotton ruling, it couldn't pay its debts or service its infrastructure. Salvation came from one-time antagonist the federal government. Under the Hoover Administration, a loan was secured through the Depression-era Reconstruction Finance Corporation. This allowed the MWD to make upgrades to the system and reinforce the dam buttresses to ensure the dam's safety. By 1936, these were completed and the drought ended. Lake Pleasant, Beardsley's dream, was a reality.

While the MWD struggled, other events were taking place that would shape the lake. The Homestead Act of 1862 attracted settlers to the area. Drawn to the more arable Salt River Valley first, the Agua Fria Valley didn't see a successful patent until 1894. Within the boundaries of the present-day Lake Pleasant Regional Park, most homesteads date from the 1920s and 1930s. This would include sheep, goat, and cattle ranching. Meanwhile, in 1922, several persons meeting in New Mexico would sign a document that sealed the fate of the yet to be constructed dam near the Frog Tanks.

The Colorado River Compact, signed by Arizona and six other states, divvied the water from that river. It would lead to the formation of the Central Arizona Project (CAP) in 1968. The portion of the waters destined for Central Arizona needed to be stored somewhere. The Bureau of Reclamation chose Lake Pleasant. In order to accomplish this, they merely needed to cause the waters of the Colorado to flow uphill more than 300 miles across the desert and back into one of its tributaries, tripling the capacity of the reservoir. This was painstakingly executed with the construction of a series of aqueducts, often referred to as the CAP Canal (begun in 1973), and the raising of the New Waddell Dam, completed in 1994.

Human presence in the Agua Fria Valley has always impacted the environment. Even though time and erosion have erased Hohokam works to the point where only a trained archaeologist can detect their presence, they did compete with or form a symbiosis with nature, as did later modern native peoples. Miners and ranchers added their impact by altering streambeds and mountainsides, releasing burros into the wild or introducing herds of goats, sheep, and cattle to compete with other foragers. However, nothing that preceded it could compare with the impact of placing a large artificial lake in the middle of the desert. From the invasion of native fish habitats to the building of a giant metropolis, Lake Pleasant, and the other reclamation projects of Central Arizona, have truly reshaped a significant portion of Planet Earth. It has ushered in a human impact in the region that, for better and worse, would be inconceivable without the stupendous technological feats of latter years.

# *One*

# THE FIRST TERRAFORMERS

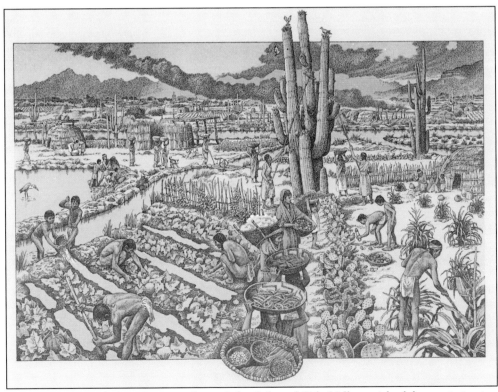

By AD 750, the Hohokam has transformed the Salt and Gila Valleys with elaborate irrigation systems. This scene depicts the canals, weirs, and laterals that were the hallmark of their activities. (Illustration by Michael Hampshire; courtesy of Pueblo Grande Museum, City of Phoenix, Arizona.)

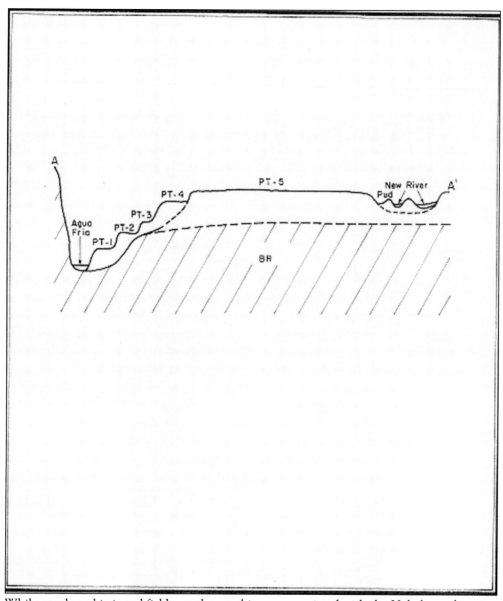

While canals and irrigated fields are the usual images associated with the Hohokam, there is a unique feature of the Agua Fria River along the region Lake Pleasant occupies today. This cross section compares the Agua Fria (left) with its tributary, the New River (right). Note that the Agua Fria lies in a deep gorge, with steeper terraced banks than the New River. Given the Hohokam limitation to stone hand tools, canal construction, while done on the New River, was not feasible along the Agua Fria. (U.S. Bureau of Reclamation, Settlement, Subsistence, and Specialization in the Northern Periphery: the Waddell Project; courtesy of Archaeological Consulting Services.)

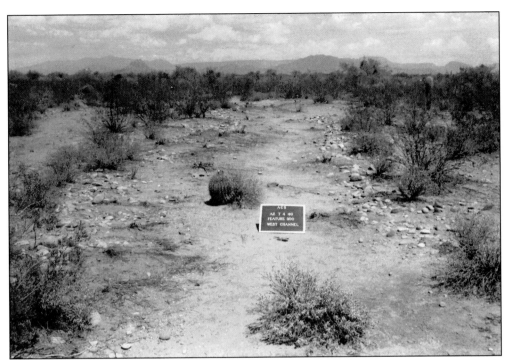

The average person hiking across this section of desert around the New River wouldn't know this is a portion of a Hohokam canal dating from about AD 700. Though filled with soil, even after hundreds of years, the desert floor remains altered by the hand of man. (U.S. Bureau of Reclamation, Settlement, Subsistence, and Specialization in the Northern Periphery: the Waddell Project; courtesy of Archaeological Consulting Services.)

This is a cross-section view of the canal featured above. If excavated and restored to its original condition, it would be almost 20 feet wide and more than 3 feet deep at its center. (U.S. Bureau of Reclamation, Settlement, Subsistence, and Specialization in the Northern Periphery: the Waddell Project; courtesy of Archaeological Consulting Services.)

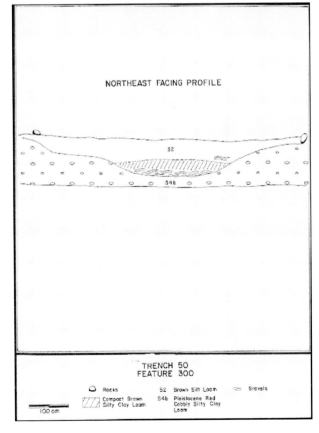

NORTHEAST FACING PROFILE

TRENCH 50
FEATURE 300

Rocks    S2 Brown Silt Loam    Gravels
Compact Brown Silty Clay Loam    S4b Pleistocene Red Cobbly Silty Clay Loam
100 cm

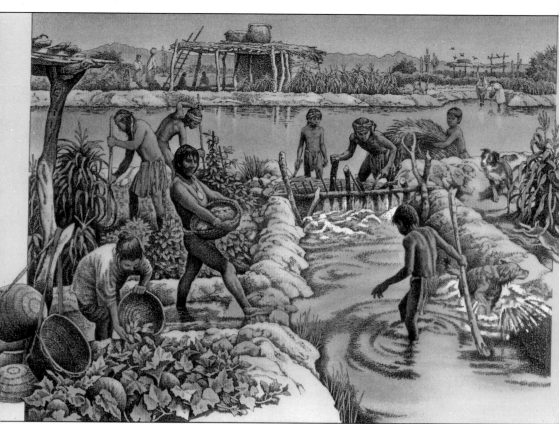

Activity along the New River canals might have looked very much like this artist's conception. A weir would extend out into the river, diverting water to a main canal (background). A head gate would regulate water flow to distribution canals (lower right). Turnouts would direct water to smaller laterals (lower left) for individual fields. Such complex works indicated a well-developed social structure and administration at the height of their civilization (around AD 1000); the Hohokam produced a surplus of crops, which included corn, beans, squash, tobacco, agave, and cotton. They traded extensively for turquoise, shells, and exotic birds as far north as the Colorado Plateau and south to the Sea of Cortez. They also constructed celestial observatories and left cryptic petroglyphs that survive to this day. Whether they fell victim to drought, disease, or climate change or whether they disappeared or were absorbed into modern tribes is still debated. (Illustration by Michael Hampshire; courtesy of Pueblo Grande Museum, City of Phoenix, Arizona.)

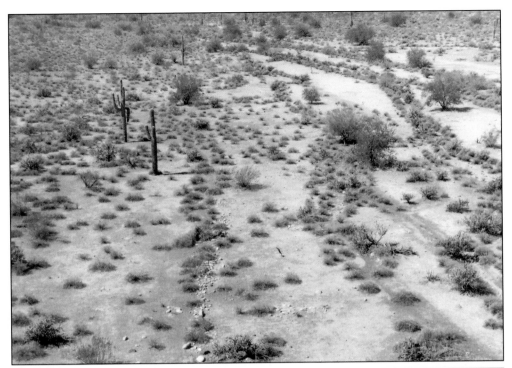

Here again is an example of an archaeological feature, this time near the Agua Fria River, which would go unnoticed to the untrained eye. The small pile of rocks extending from the bottom of the photograph above, just left of center, was placed there by human hands. This is an example of water management that takes advantage of a feature known as swales. To the right is a field diagram of this same feature. Swales are small depressions in the land. In this case, they occur on natural terraces along the slope toward the river. The Hohokam would pile rock barriers around these to trap runoff water and sediments. These would then serve as moist plots in which to plant crops. (Both, U.S. Bureau of Reclamation, Settlement, Subsistence, and Specialization in the Northern Periphery: the Waddell Project; courtesy of Archaeological Consulting Services.)

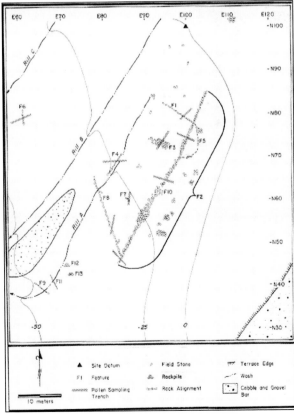

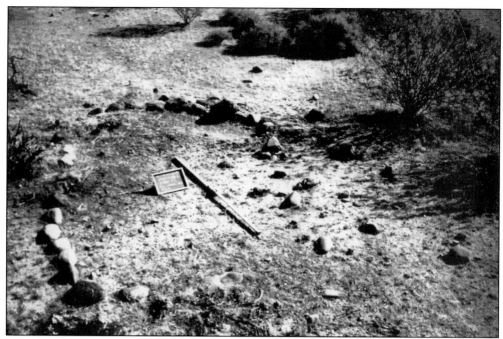

The foundation of a Hohokam field house near Lake Pleasant (above) is juxtaposed with an artist's rendering (below). Unlike the more sophisticated pit houses and adobe compounds, these were simple structures. Oval shaped and constructed of brush, these dwellings were located in direct proximity to their crops. They were occupied during times of intensive work in the fields when a commute between one's home in the pueblo and the crops was wasteful. These were single dwellings and might have also served to establish ownership of a particular piece of fertile ground. (Above, U.S. Bureau of Reclamation, Settlement, Subsistence, and Specialization in the Northern Periphery: the Waddell Project; courtesy of Archaeological Consulting Services; below, illustration by Michael Hampshire; courtesy of Pueblo Grande Museum, City of Phoenix, Arizona.)

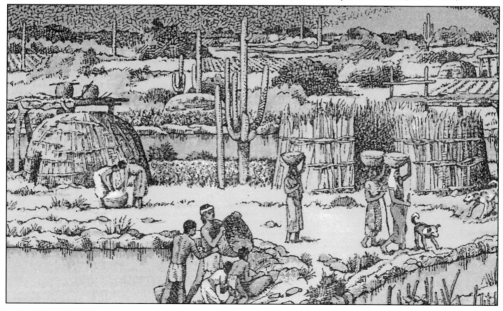

Near the north end of Lake Pleasant Regional Park, Indian Mesa (above) is viewed from about 3 miles away. Around AD 1000, the Hohokam deemed it necessary to build a fortified retreat overlooking the Agua Fria. This location could only be scaled from a steep, narrow trail on one side. Seen from the top of the mesa (below), this position is easily observed, as are all other approaches. Moreover, fortifications like this were located within line of sight of each other so they could alert one another of the approach of anyone, friend or foe, well in advance of their arrival. The area is now a protected archaeological site under federal law. (Both, author's collection.)

This is the view seen from the only approach, on the trail to the top of Indian Mesa. At this point, the trail narrows to a steep footpath with a vertical cliff on one side and a long fall on the other. Both hands and feet are required to pull oneself up and around the wall seen here. Note the viewing port at the lower center just right of the ocotillo. A word from the sentry standing on the other side would bring down a hail of boulders positioned atop the aforementioned cliff. Below is the view from the sentry's position on the other side of the wall. Lake Pleasant can be viewed in the background. (Both, author's collection.)

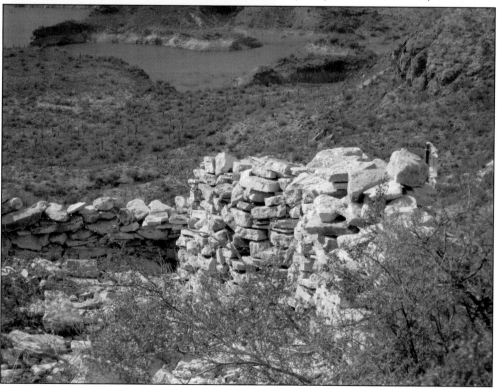

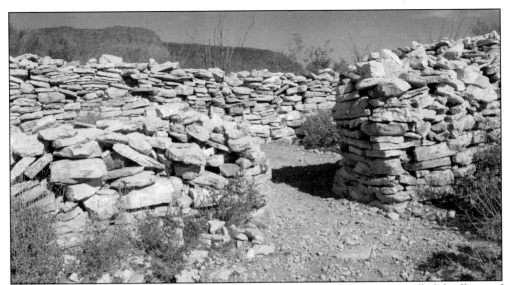

Here is one of the well-preserved buildings found atop Indian Mesa. Four-walled dwellings of stacked-stone masonry construction, made from materials found on-site, characterize the ruins. It is not likely that the Hohokam occupied the site year-round. More likely, it was pre-supplied with provisions and used as a retreat in the event of an attack. (Author's collection.)

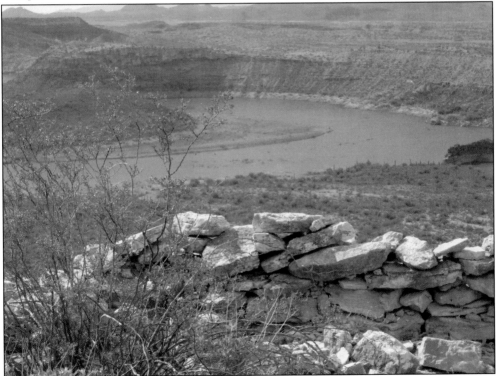

Seen here is a view of Lake Pleasant seen from the fortified Indian Mesa at a bend in the Agua Fria. During the time the Hohokam occupied the area, the low, flat terrace exposed by a lower lake level would have offered them opportunities to apply the farming methods outlined earlier. They probably spent most of the year closer to the river, tending their crops. (Author's collection.)

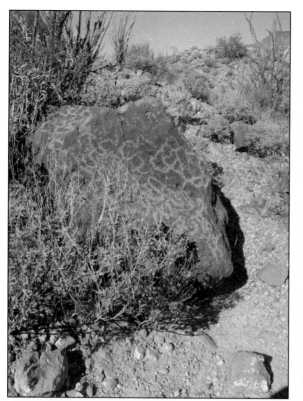

Cryptic petroglyphs, some now beneath the waters of Lake Pleasant, are the only messages left along the Agua Fria from the Hohokam. What they were telling is little understood. What is known is that they were gone from the area by around AD 1250, a few hundred years sooner than their disappearance from the Salt River Valley below. This may support theories that their exit was prompted by climate change, such as an extended period of drought. The Salt River, with its more reliable water supply, might have supported a lingering presence. Other ideas include encroachment and absorption by other Indian groups, salinization of the soil from over-irrigation, disease, overpopulation, flooding, or any combination of these things. (Both, author's collection.)

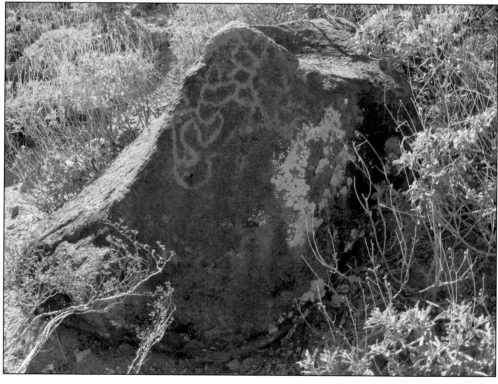

# Two

# NOMADS, MINERS, AND PIONEERS

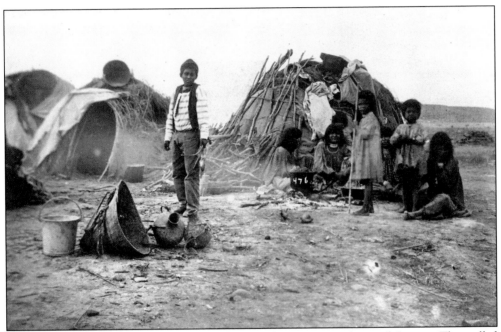

After the Hohokam, the Yavapai hunted and gathered in western and central Arizona. They called the Agua Fria Pauwiwaskimi and traveled there extensively. They harvested agave and saguaro cactus fruit and lived in brush homes, known as oo-wahs (popularly referred to as wickiups), such as those pictured above (around 1890). The discovery of gold in the area in 1863 proved a catastrophe for them. As miners and settlers moved in, the U.S. Army established forts on their traditional lands. After the army declared them hostile in 1864, they were hunted relentlessly. Though they retaliated, they were simply outnumbered and outgunned. By 1872, they were relocated to the Camp Verde Reservation. In 1875, after a disastrous winter march in which many died, they were settled on the San Carlos Reservation 180 miles away. In 1903, the Yavapai requested to be returned to the Camp Verde area to what eventually became the Camp Verde Yavapai-Apache Reservation in 1937. Theodore Roosevelt (1903) declared that Fort McDowell become a home for the Yavapai. The Yavapai-Prescott reservation was established in 1935 on the former site of Fort Whipple. (Courtesy of Sharlot Hall Museum, Prescott, Arizona.)

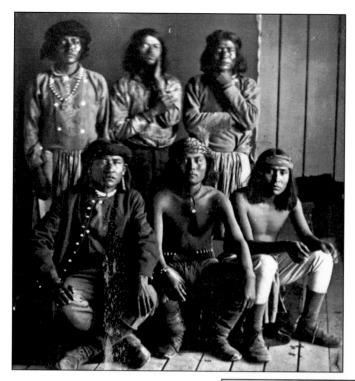

Yavapai, such as this *c.* 1870 group from Camp Verde, were recruited as scouts by the army. Among their most notable campaigns was their participation in the capture of the famous Chiricahua Apache Geronimo in 1886. (Courtesy of Sharlot Hall Museum, Prescott, Arizona.)

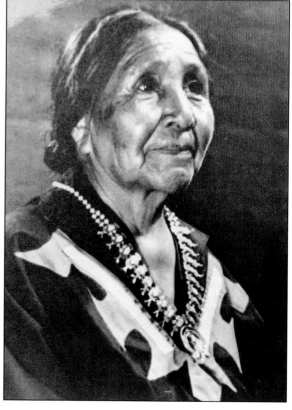

Viola Jimulla (1878–1966), here around 1960, is perhaps the most famous among the Yavapai. She became chief in 1940. A member of the Arizona Women's Hall of Fame, she was instrumental in the creation of the Yavapai-Prescott Reservation as well as the Yavapai College in Prescott. She was also an accomplished basket weaver, a craft for which the Yavapai are renowned. (Courtesy of Sharlot Hall Museum, Prescott, Arizona.)

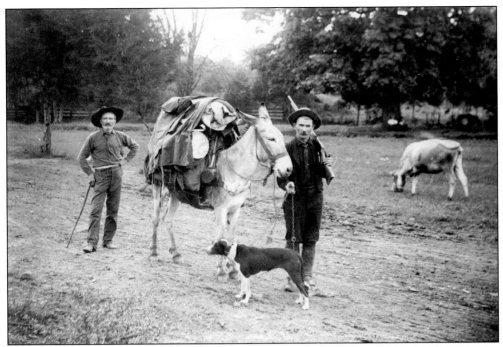

Gold brought prospectors into the Agua Fria watershed in droves. Pictured are typical prospectors and their burro around 1898. Their "capital investment" was usually limited to what is seen here: mining equipment, food, weapons, and a tent, all carried by the trusty burro. When the gold played out, claims were frequently abandoned, often along with the burros, which linger around Lake Pleasant today. (Courtesy of the Library of Congress, LC-USZ62-103294.)

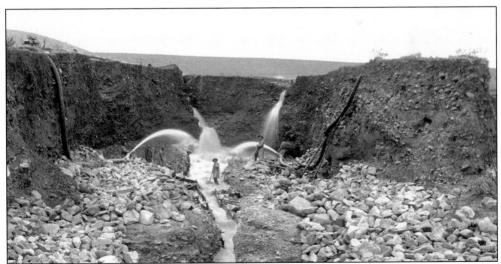

Miners practice hydraulic mining on Lynx Creek around 1890. It was also done on Humbug Creek, both tributaries of the Agua Fria. It used large volumes of water to dislodge rock and sediment. Material was run through a long wooden channel called a sluice, where heavier gold deposits would collect. The effect on the river was dramatic and devastating to riparian areas. (Courtesy of Sharlot Hall Museum, Prescott, Arizona.)

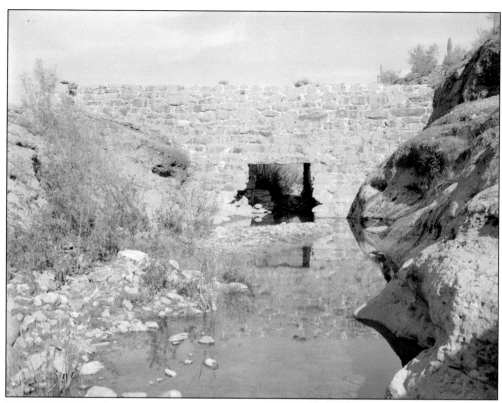

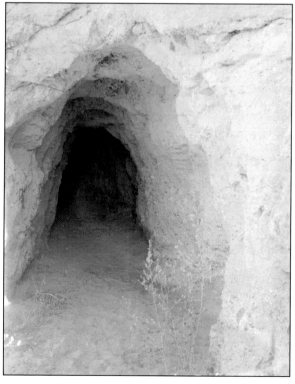

Hydraulic mining quickly displaced the lone prospector. One of the most ambitious projects was located on Humbug Creek, which feeds directly into present-day Lake Pleasant. These 1986 photographs show the dam (above), often referred to as the China Dam, and tunnel (below). They were constructed in 1890 by the Humbug Creek Placer Mining Company, also known as the Yavapai Mining and Irrigation Company. A control gate was located on the opening at the bottom of the dam. The tunnels, which are filling with silt, were part of a ditch system that extended for more than a mile to feed the hydraulic operations. The mine failed to produce gold in sufficient quantities to make it viable and was out of operation by 1893. (Both, courtesy of the Library of Congress; above, HAER ARIZ, 7-PHEN.V, 5-49; below, HAER ARIZ, 7-PHEN.V, 5-51.)

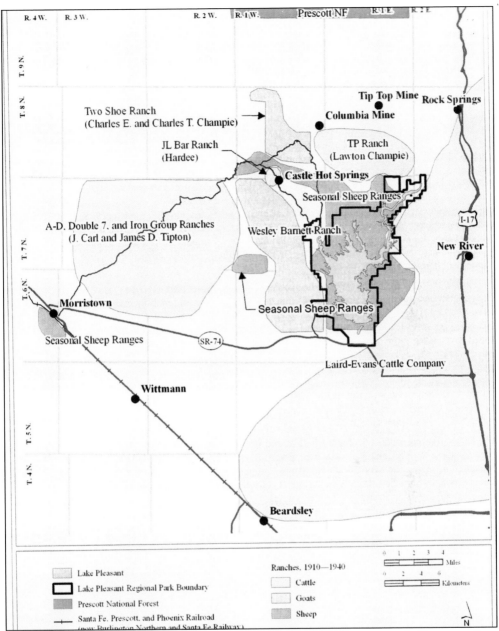

This map shows ranching around Lake Pleasant during the most active period of homesteading, 1910–1940. The area, with its steep canyons and rocky soil, was less desirable for farming than the Salt River Valley. While better suited for ranching, only limited acres of grazing lands were available for profitable ranching. The Arizona State Land Department (1915) and the Pleasant Dam (1926) withdrew much of the lands from the public. Nevertheless, some successful patents were granted within present-day park boundaries, starting with Thomas Holland in 1907. Most of the patents were granted by the late 1920s and would have likely ended there were it not for the Great Depression of the 1930s, which led some people to attempt homesteads as a means of subsistence. The locality known as Beardsley (bottom) was a sheep station located on land acquired from the Santa Fe Railroad. (Courtesy of the U.S. Bureau of Reclamation.)

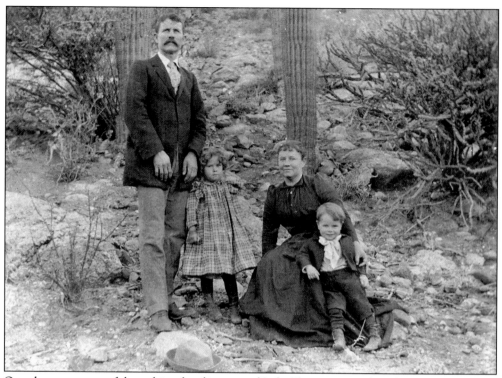

One the most successful ranching families around Lake Pleasant were the Champies. Charles E. and Elizabeth Champie, seen above in 1900 with their children, Annie and George, established the Two-Shoe Ranch in 1908 raising Angora goats (below). Goats and sheep became the dominant stock around Lake Pleasant. Angora were raised primarily as the source for mohair but were also used for milk and meat. Champie goats attracted a cheese factory, operated by Greek immigrants. Goat meat was in demand during World War II as a result of rationing of beef. During the 1940s, Yavapai County accounted for about half the Angora in Arizona. However, the demand for Angora products declined sharply after the war, and they disappeared from the area. The Champie brand lived on through the efforts of Lawton Champie, who raised cattle on the TP Ranch. (Both, courtesy of Sharlot Hall Museum, Prescott, Arizona.)

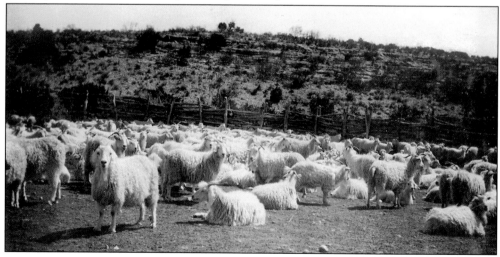

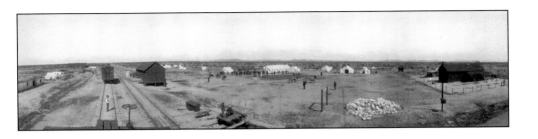

Beardsley, Arizona, in 1908 (above) had a sheep shearing station located by the Santa Fe Railroad. It was situated on land within the Agua Fria Water and Land Company service area, named in honor of William Beardsley's efforts to bring irrigation west of Phoenix. A post office, located there in 1936, was gone by 1940. Tracks still run through the area, as seen in the 2009 photograph (below) of the same place. Not much seems to have changed in 100 years; however, on both sides of the tracks is Surprise, Arizona, founded in 1938 by Homer C. Ludden with a population of nearly 100,000. Since 1950, it has been the headquarters of the Maricopa Water District, present-day incarnation of the Agua Fria Water and Land Company. (Above, courtesy of the Library of Congress, pan 6a00527; below, author's collection.)

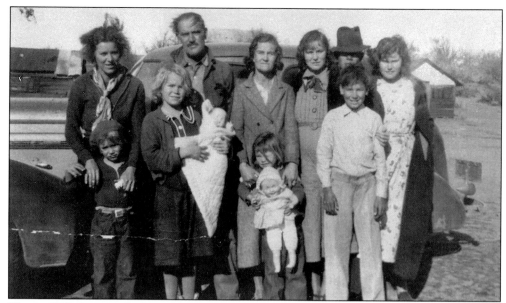

This c. 1933 photograph shows Charles Brown (second row, second from left), his wife, Ora Lee (second row, third from left), and their family living on their homestead. Pictured, in no particular order, are daughters Jettie, Onetta, Luiedell Victoria, and Mildred; J. D., the eldest son; Carroll, the youngest son; Jettie's daughter Alberta; and Onetta's daughter Bobby. Brown was a farmer and carpenter who worked on the Old Waddell Dam. He was building homes in Phoenix when the Depression hit. After going broke, he settled north of Lake Pleasant. (Courtesy of the U.S. Bureau of Reclamation.)

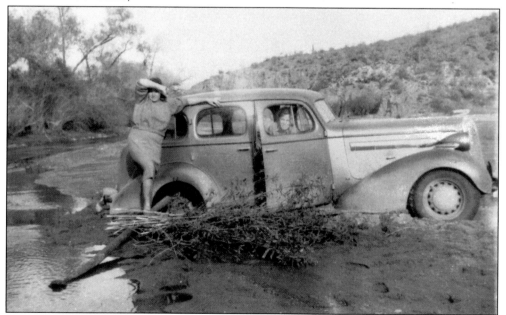

Jettie Brown Tyler, eldest of the Brown children, has her car stuck in the Agua Fria mud around 1933. Onetta is most likely the other woman in the photograph. The available homestead land in Arizona during the 1930s was usually remote and devoid of maintained roads. (Courtesy of the U.S. Bureau of Reclamation.)

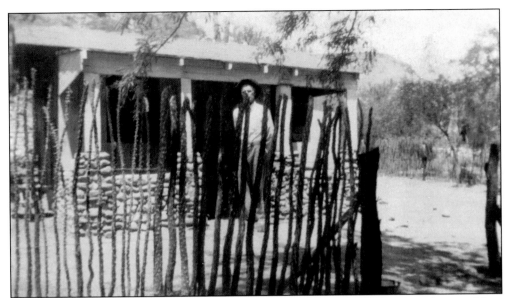

Charles Brown is at his second home on the homestead (above); the first was destroyed in a flood. The Browns derived a marginal income from cutting and selling firewood. They also raised goats, pigs, and chickens, mostly for food and milk. He tried his hand at citrus farming, but the goats destroyed the trees. Originally, the Browns simply moved on to the land as "squatters." Nevertheless, Brown managed to improve the 160-acre plot and gain a patent around 1943. The land was eventually sold to a cattle company and fell into disuse. It is now within the boundaries of Lake Pleasant Regional Park. All that remains of the house can be seen in the 1988 photograph below, when it was surveyed by archaeologists for the Bureau of Reclamation. (Both, courtesy of the U.S. Bureau of Reclamation.)

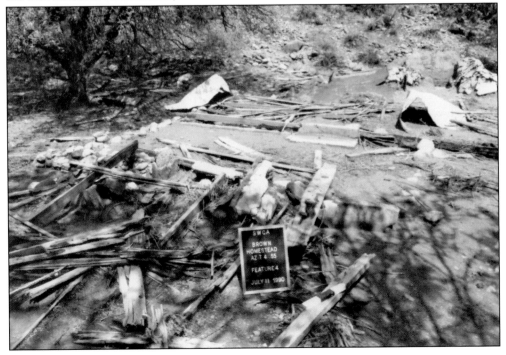

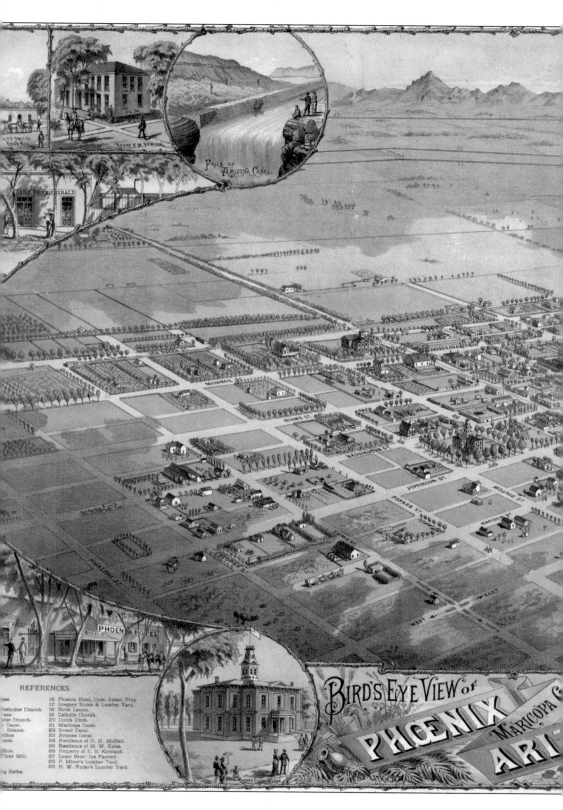

Falls on
Arizona Canal.

BIRD'S EYE VIEW of
PHOENIX
MARICOPA C
ARI

30

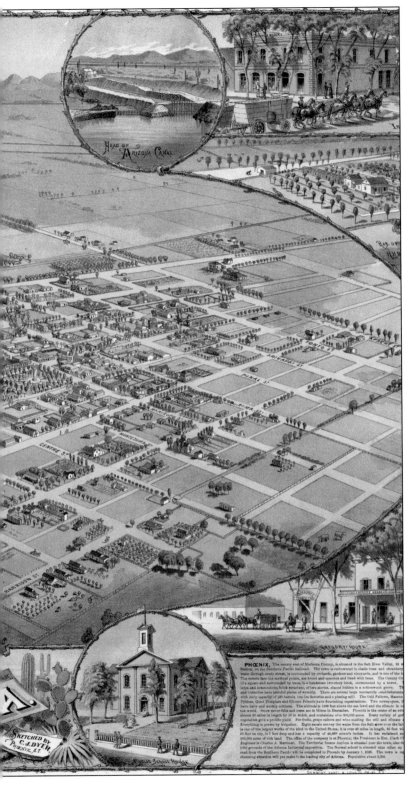

Phoenix in 1885 is depicted in this bird's-eye view by C. J. Dyer just nine years before the attempted construction of the Camp Dyer Diversion Dam and the Beardsley Canal. The border illustrations show that irrigation was well on its way to establishing the young town as the major agricultural center in the territory. Projects, like construction of the Arizona Canal, no doubt encouraged Beardsley and his investors as to the feasibility of their plans. Beardsley hired C. (Czar) J. Dyer, a draftsman and future mayor of Phoenix, to survey the location for a work camp from which to bring to fruition the initial phase of the Frog Tanks project. The location, established in 1882 on the east bank of the Agua Fria, would become known as Camp Dyer, as would the diversion dam. (Courtesy of the Library of Congress, LC-DIG-pga-00435.)

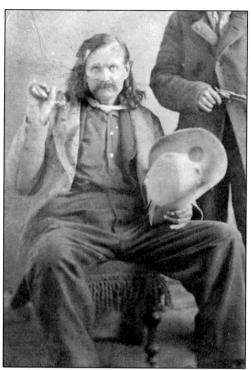

Jack Swilling, one of the first prospectors in Yavapai County, poses around 1870. His gold discoveries ushered in the gold rush of 1863. His Swilling Irrigating and Canal Company helped establish Phoenix in 1867, after which he returned to Yavapai County and built a home in Black Canyon City on the Agua Fria River. His irrigation efforts inspired others after him, including the Beardsleys. (Courtesy of Phoenix Public Library.)

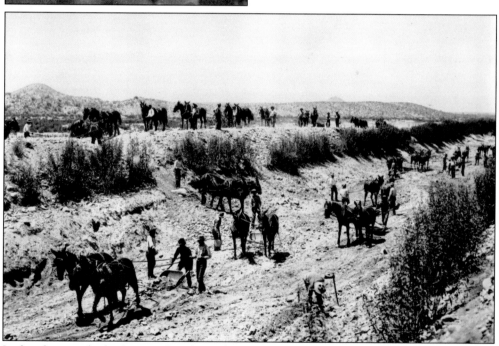

In this photograph, the Arizona Canal is undergoing scraping in 1908. Constructed by the Arizona Canal Company in 1883, this canal, like most early irrigation efforts in the Salt River Valley, was achieved through private enterprise. The Agua Fria Water and Land Company would be the most ambitious of these private efforts. (Courtesy of the Library of Congress, HAER ARIZ, 7-PHEN.V, 1-6.)

# *Three*

# THEN CAME BEARDSLEY

Pictured around 1920, William Henry Beardsley was born November 13, 1850, in Hamilton, Ohio, and attended Miami University in Oxford, Ohio. He married Ida Oglesby of Middletown, Ohio, and together they had a son, Robert Oglesby Beardsley. If any one person could be credited with the success and creation of Lake Pleasant, it would be William Beardsley. He overcame every challenge that man or nature brought and stubbornly guided the project until his last breath. (Courtesy of the Salt River Project.)

The Agua Fria Water and Land Company was incorporated in 1888 by William A. Hancock, James D. Monihon, John P. Orme, Lindley Orme, and Robert B. Todd. Pictured around 1895 is Lindley Orme. As Maricopa County sheriff, he had the unpleasant task of auctioning the assets of his own company after it went bankrupt in 1895. William Beardsley recovered those assets nonetheless. (Courtesy of Fraternal Order of Police, Maricopa Lodge 5.)

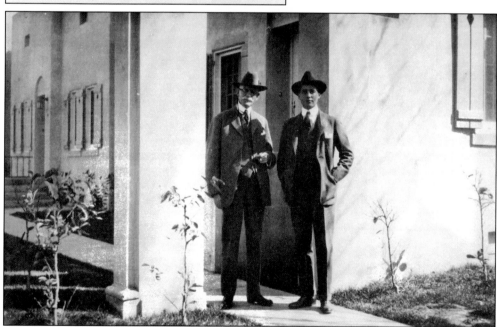

Shown here are William Beardsley (left) and his son, Robert Oglesby Beardsley, around 1920. Robert was born in 1889 and was raised by relatives in Ohio while his father attended to business in Arizona. He attended Yale University, joining his father in Arizona after graduation. Robert took over from his father after William's death in 1925. (Courtesy of the Library of Congress, HAER ARIZ, 7-PHEN.V, 5-8.)

This is an example of a first-series, $1,000 bond that was issued in 1925. These were the instruments that William Beardsley used to fund construction of the Maricopa Water District. They were the same bonds that investment firm Brandon, Gordon, and Waddell acquired, thus bringing Donald Waddell into the project, and the same ones that chief engineer Carl Pleasant would accept as payment for his work. (Courtesy of the Maricopa Water District.)

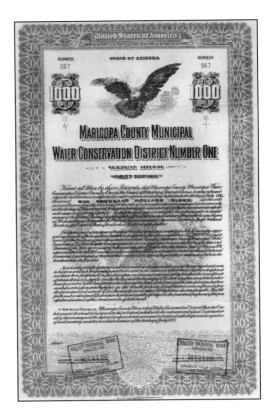

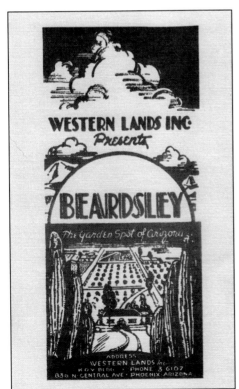

This c. 1928 brochure was used to sell potential investors on buying land within the service area of the private reclamation project, the Maricopa County Municipal Water Conservation District No. 1, also known as the Maricopa Water District. The MWD is the unique exception to most reclamation projects, which were almost exclusively government-backed projects. (Courtesy of the U.S. Bureau of Reclamation.)

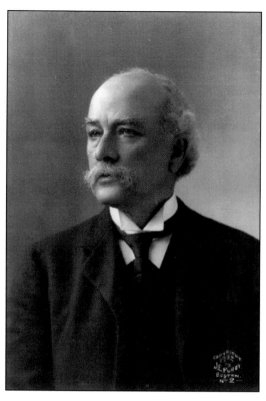

Two men who became William Beardsley's antagonists were Ethan Allen Hitchcock (left), 22nd U.S. Secretary of the Interior, and Frederick H. Newell (below), first director of the U.S. Reclamation Service. Hitchcock was appointed to serve in President McKinley's cabinet as well as Theodore Roosevelt's. His withdrawal of public land under the Newlands Act threatened to end the Beardsleys' plans. Newell, an MIT graduate and engineer, showed disdain for the project from the beginning. He required engineers to predict from month to month how much water would be in the lake and how much would be drawn without knowing how much land would be under cultivation or what crops would be planted. He held this position for seven years while the Salt River Project apparently went forward with no such requirements. (Both, courtesy of the Library of Congress; above, LC-USZ62-66577; below, LC-USZ62-66576.)

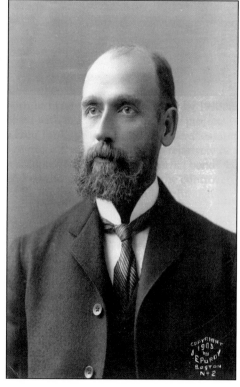

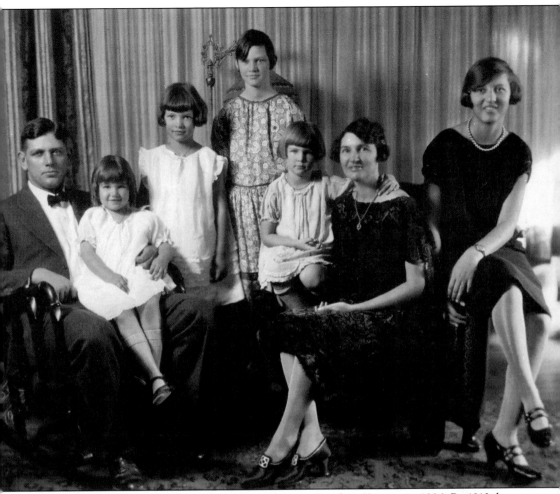

Carl Pleasant sits with his family in 1927. He was born in Lyndon, Kansas, in 1886. By 1910, he held a graduate degree in engineering and was involved with many civil engineering projects by the time William Beardsley tapped him to head the Frog Tanks project in 1919. Under Pleasant's guidance, the company selected a multiple-arch design for the storage dam—a relatively new design at the time. As payment for his work, Pleasant accepted Maricopa Water District bonds. He would carry the greatest share of the burden of defending the dam's safety when the controversy over cracks appearing in the buttresses erupted. Like Beardsley, he saw the project through dark days only to die on the eve of success. He passed away in 1930 at the age of 43. (Courtesy of the Library of Congress, HAER ARIZ, 7-PHEN.V, 5-47.)

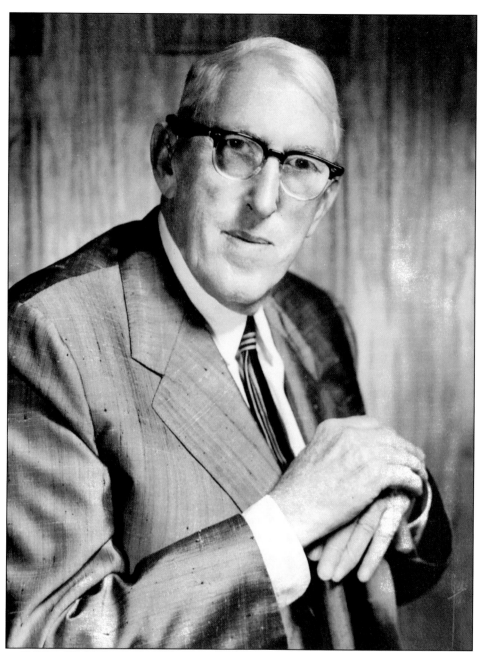

Donald Ware Waddell sits, posing for an undated portrait. Like the Beardsleys, Donald Waddell hailed from Ohio. His firm, Brandon, Gordon, and Waddell of New York, purchased the entire bond issue for the Frog Tanks Project. Having spent some winters in Arizona, he was sent to Phoenix to oversee the project and became infected with the same enthusiasm for it as William Beardsley. He acquired land in the project service area and moved his family to what became known as the Waddell Ranch. He remained dedicated to the project until his death in 1963. At that time, the dam was renamed the Waddell Dam, as was the New Waddell Dam that would be built by the Bureau of Reclamation between 1987 and 1993. (Courtesy of the Library of Congress, HAER ARIZ, 7-PHEN.V, 5-48.)

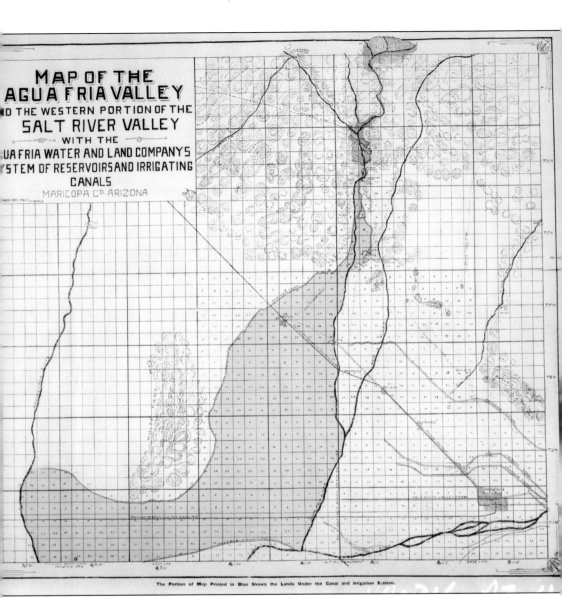

The Portion of Map Printed in Blue Shows the Lands Under the Canal and Irrigation System.

This map shows the original service area for the Agua Fria Water and Land Company in 1895. The ambitious plan surveyed five different dam sites and anticipated two canals to deliver water to 160,000 acres. When engineer George Beardsley learned of the project while visiting Phoenix, he became fascinated with its potential and was sure it could be built—so sure that he organized the Agua Fria Construction Company, whose sole purpose was to bring the project into existence. Upon his death, it would become his brother's project. It was William Beardsley's sole endeavor in life for 33 years. The shaded area indicates acreage that was to be "reclaimed" by the project. These were the lands withdrawn under the Newlands Reclamation Act of 1902 by Interior Secretary E. A. Hitchcock, thus leaving the Water and Land Company with no potential customers to serve. (Courtesy of the Library of Congress, HAER ARIZ, 7-PHEN.V, 5-7.)

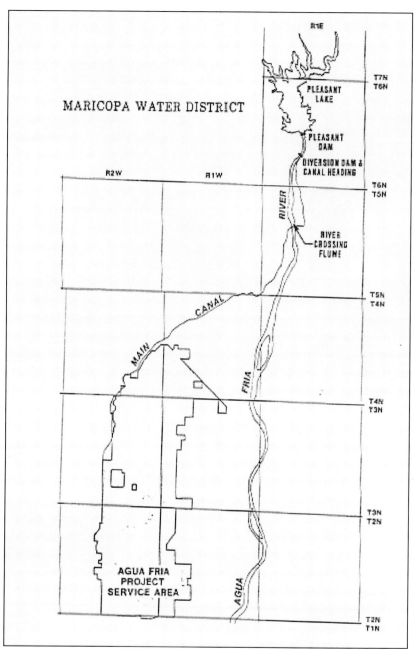

This map shows the actual service area of the Maricopa Water District and Lake Pleasant, prior to construction of the New Waddell Dam (about 1988). The service is about 40,000 acres, only a fraction of the 160,000 envisioned by creators of the Agua Fria Water and Land Company. The storage dam held 156,000 acre-feet of water. The diversion dam created a smaller, lower lake of about 400 acre-feet. Only one main canal was built—the Beardsley Canal, which extends for 33 miles, ironically the number of years William Beardsley devoted to the project. Most of it lies west of the Agua Fria River, after it crosses the river via a flume. Lands receiving MWD water have been producing such crops as cotton, citrus, vegetables, grapes, grain, flowers, trees, and even golf courses since the 1930s. (Courtesy of the U.S. Bureau of Reclamation.)

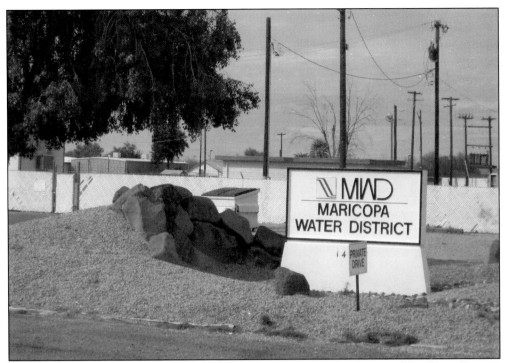

William Beardsley owned land within the MWD service area near the Beardsley Sheep Station. Beardsley was the intended name for the town MWD promoters perceived for the area. It eventually became part of Surprise, Arizona. The Maricopa Water District headquarters, seen in these 2009 photographs, has been located there, just west of the railroad tracks, since the 1950s. To this day, the MWD remains as the most successful privately funded reclamation project in the United States. Despite numerous challenges—technical, legal, and financial—throughout its history, it remains a profitable business today. In addition to retaining rights to their share of water in current-day Lake Pleasant, they also own the Pleasant Harbor facility, located on 255 acres on the lake. (Both, author's collection.)

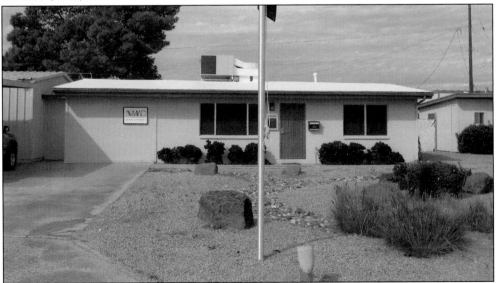

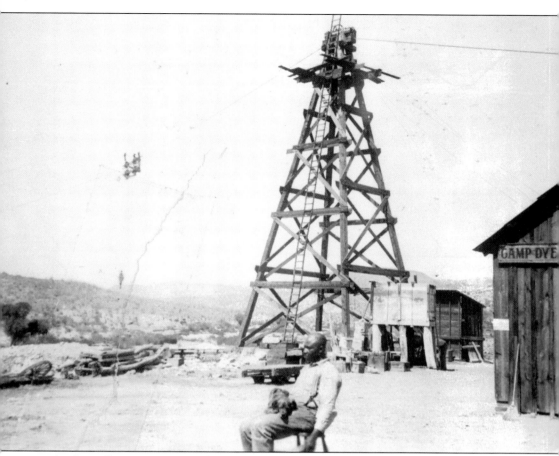

At Camp Dyer in 1903 is Robert "Jerry" Jones, who joined Beardsley's effort in 1893, doing construction work and tending company livestock at a corral located there. He stayed on as watchman for 21 years even though Beardsley didn't pay him any wages. Apparently, Beardsley supplied him room and board, including enough provisions for Jones to make a business of servicing travelers on the stage route through the area. Camp Dyer became a well-known stop where people could spend the night. They may have stayed in the bunkhouse located just behind Jones. The tower supported a cableway used in the first construction attempt of the Camp Dyer Diversion Dam and the Beardsley Canal. Jones's presence on the property helped Beardsley maintain his claim to the land. Jones retired and moved to Phoenix in 1916. From that time on, Jones, who would outlive his boss, was paid regularly by the Beardsleys, William and then son Robert, for the time he spent watching over Camp Dyer. (Courtesy of the Library of Congress, HAER ARIZ, 7-PHEN.V, 5-6.)

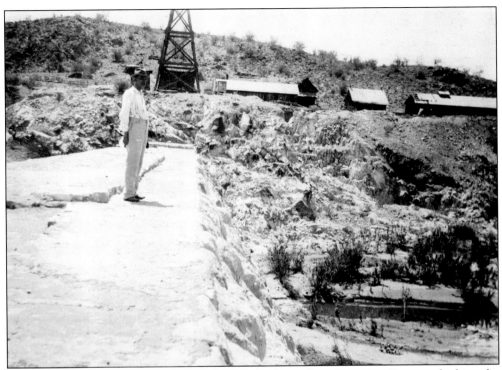

In 1903, above, William Beardsley stands atop the Camp Dyer Diversion Dam overlooking the Agua Fria River with Camp Dyer in the background. Camp Dyer was located on a wide terrace of the type the Hohokam might have used to catch runoff in swales. Below, he poses by the canal that bears his name, also only partially complete. The photographs in this book dated 1903 originally appeared in the Schuyler Report, the study undertaken by Beardsley at the request of the Reclamation Service. It was prepared by engineer James Dix Schuyler. Despite its thoroughness, additional data was requested by the Reclamation Service. (Both, courtesy of the Library of Congress, HAER ARIZ, 7-PHEN.V, 5-4 and 5.)

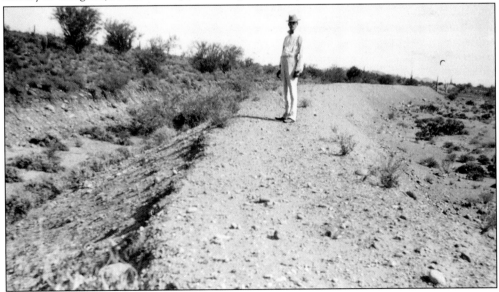

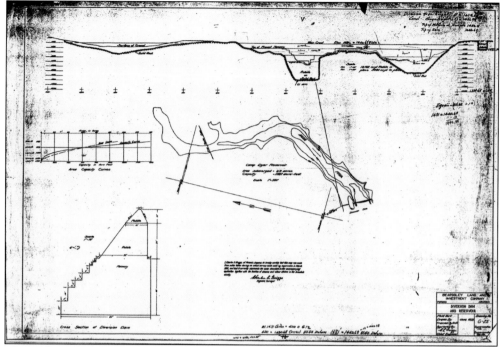

These blueprints of the Camp Dyer Diversion Dam from 1895 illustrate how water was raised above the inner gorge, behind the dam, to the point where it could be fed into canal head gates, on the east terrace. This was how Beardsley solved the problem the Hohokam could not—how to build a gravity-fed canal on the Agua Fria River. (Courtesy of the Library of Congress, HAER ARIZ, 7-PHEN.V, 5-80.)

A 1903 upstream view shows the Camp Dyer Diversion Dam. The Agua Fria River is notorious for flooding. It was one such flood in October 1895 that nearly ended the project. The portion damaged by flooding eight years prior can be seen in the center. (Courtesy of the Library of Congress, HAER ARIZ, 7-PHEN.V, 5-3.)

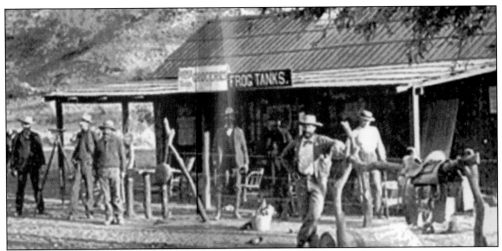

The Frog Tanks Station is shown in an undated photograph on the Agua Fria River, northwest of Phoenix. It was on the stage route to Castle Hot Springs and also supplied local miners. Also known as Pratt, it was a few miles downstream of the confluence of the Agua Fria and Castle Creek. It became the storage dam site for the Agua Fria Water and Land Company. (Courtesy of Lake Pleasant Regional Park.)

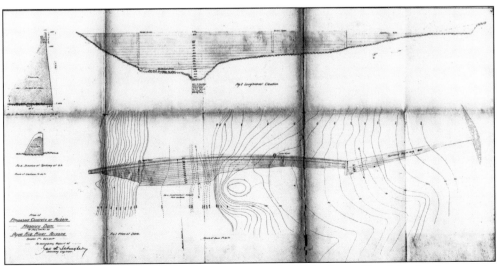

The original plans for the Frog Tanks Dam are dated 1903 by James Dix Schuyler. It was to be a massive gravity dam, made of concrete and rubble masonry, requiring 160,000 cubic yards of material. The tremendous cost of such a structure caused Carl Pleasant to steer William Beardsley in another direction, reaching back to an ancient form—the arch. (Courtesy of the Library of Congress, HAER ARIZ, 7-PHEN.V, 5-77.)

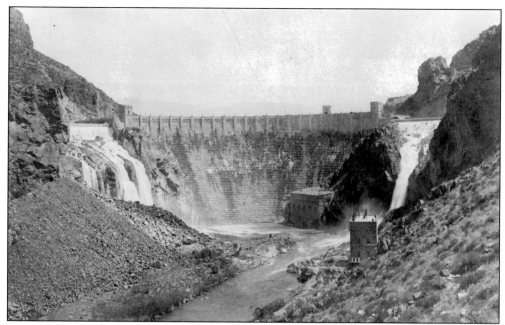

Gravity dams such as Roosevelt Dam on Arizona's Salt River (around 1915), although incorporating the arch in their design, rely mainly on their tremendous weight to hold water back. Upon its completion in 1911, Roosevelt Dam was 280 feet high and 720 feet in length, requiring 342,000 cubic yards of masonry at a cost of around $10 million. (Courtesy of the Library of Congress, LC-USZ62-106346.)

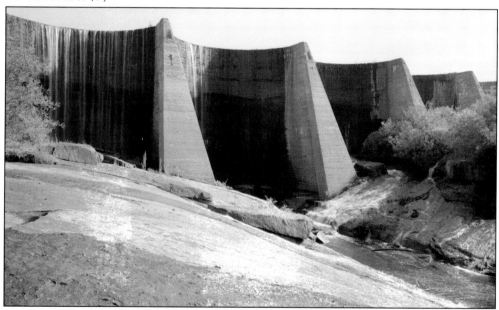

The United States' first multiple-arch dam, Hume Lake Dam in California, was designed by John S. Eastwood and completed in 1909. Arch dams carry the water's weight to the dam's abutments. Multiple-arch dams carry weight across the arches to the buttresses, spanning wider spaces and using less material. This design concept was selected by Peckham and James for the Frog Tanks dam. (Courtesy of the Library of Congress, HAER CAL, 10-HUME, 1-6.)

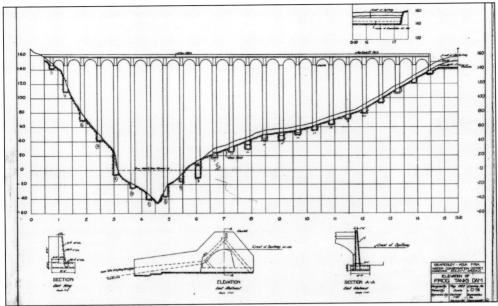

The first Peckham and James design for the Frog Tanks Dam, in 1925 (above), spanned straight across the river at 1,800 feet at the crest and 174 feet above the bed. Because of bedrock conditions, plans were modified to a "V" formation (below). Discharges were planned through three 6-foot diameter penstocks at the dam's base, one for river discharge and two for hydroelectric power. The 29-gate spillway was located northwest of the dam. At 154 feet above the bed, it was designed to discharge 105,000 cubic feet per second. It would be the world's tallest multiple-arch dam, impounding up to 173,000 acre-feet of water. It required 75,000 cubic yards of material at a total cost of $3.3 million. (Above, courtesy of the Library of Congress, HAER ARIZ, 7-PHEN.V, 5-82; below, courtesy of the U.S. Bureau of Reclamation.)

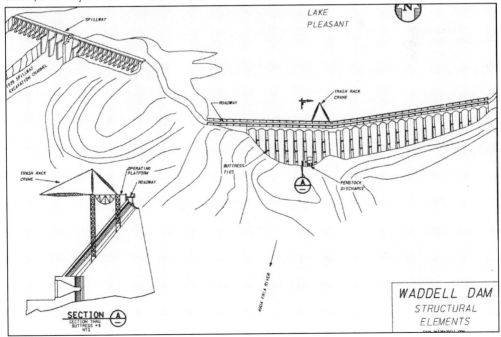

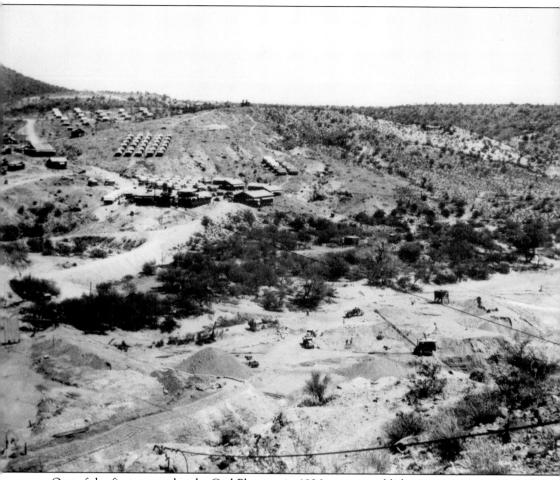

One of the first steps taken by Carl Pleasant in 1926 was to establish construction camps—the main camp, at Frog Tanks, on the east side to the river with tent housing on the west bank; Camp Dyer, at the diversion dam, also on the east bank; and one 4 miles downstream at the site where a flume was to be constructed to bring the Beardsley Canal from the east to the west bank of the river. This 1927 photograph was taken at the west abutment of the dam. In the foreground by the large excavator is the borrow, where sand and aggregate were gathered from the riverbed. On top of the terrace, in the center, are the construction shops, and in the background is the housing area. (Courtesy of the Library of Congress, HAER ARIZ, 7-PHEN.V, 5-29.)

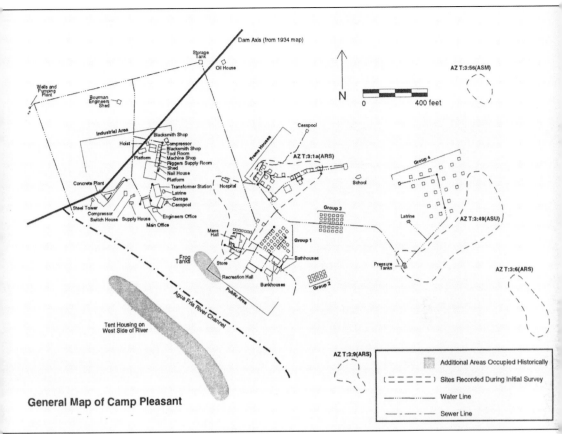

**General Map of Camp Pleasant**

Camp Pleasant, as seen in this map dated 1934, was a far cry from the hardscrabble conditions of Camp Dyer of 1895. Then there was little more than a few frame buildings and tents, which housed about 125 men—no families. Included among the living areas were the construction areas and storage, including explosives, no water system, and no latrines. At its peak, Camp Pleasant housed around 1,000 workers, their wives, and children. There was a school, bathhouses, recreation hall, store, hospital, and housing for single men and married men with families. Included in the separate industrial area of the camp were blacksmith shops, a tool room, nail room, transformer, concrete plant, water pumping station, a well, and a sewage system. (Courtesy of the U.S. Bureau of Reclamation.)

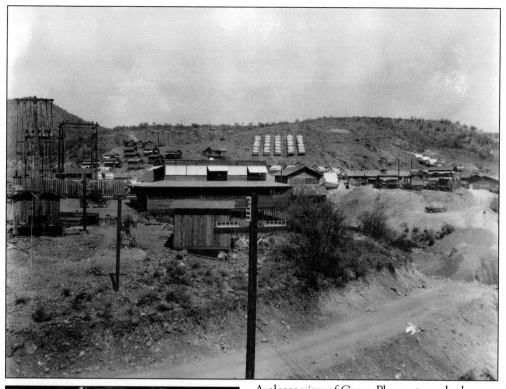

A closer view of Camp Pleasant overlooks the construction area in 1926 (center). The housing units can be seen on the hillside just above. The white buildings were tent housing units, typical of work camps of the day. Note the utility poles. Electricity and running water, both featured at Camp Pleasant, were unheard of in 1895 when Camp Dyer first opened. (Courtesy of the Salt River Project.)

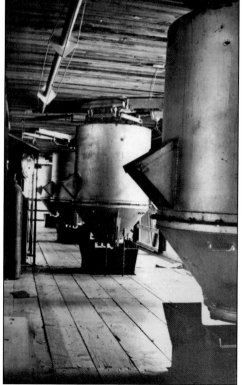

Camp Pleasant included its own cement plant. Seen here around 1926 are the concrete storage silos, which held concrete ready to mix with water. While sand and gravel were taken directly from the river bed, Portland cement, the main ingredient in modern concrete, had to be brought in—108,000 barrels were required. (Courtesy of the Library of Congress, HAER ARIZ, 7-PHEN.V, 5-12.)

Before concrete could be poured, the river was diverted and excavation work was required. This meant digging and blasting down to bedrock, which at the dam site was between about 13 to 40 feet below the river channel. Approximately 80,000 cubic yards of riverbed was removed. The storage dam, by now renamed the Pleasant Dam (after Carl Pleasant), was mainly a series of buttresses and arches. These 1926 photographs show abutment (above) and arch foundation (below) work as they are preparing the bedrock to receive concrete. (Above, courtesy of Salt River Project; below, courtesy of the Library of Congress, HAER ARIZ,7-PHEN.V,5-10.)

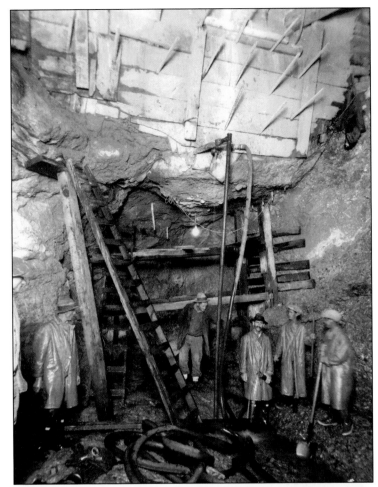

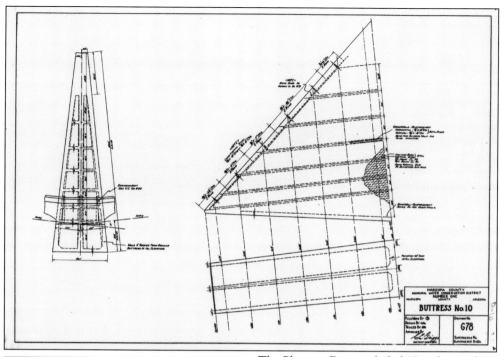

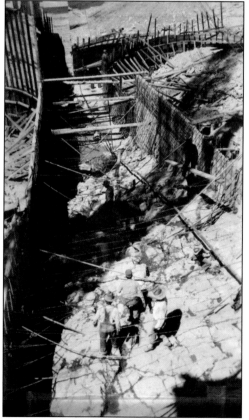

The Pleasant Dam included 27 arches and 28 buttresses. Each of them, as well as the other components of the project, required its own blueprints. This is the blueprint for buttress no. 10 from 1925. Note that the buttresses were hollow inside. (Courtesy of the Library of Congress, HAER ARIZ, 7-PHEN.V, 5-96.)

In this photograph, dated 1926, blueprints are converted into tangible results as buttress no. 10's foundation is carved into the bedrock. A form for the concrete is going up around it. (Courtesy of the Library of Congress, HAER ARIZ, 7-PHEN.V, 5-15.)

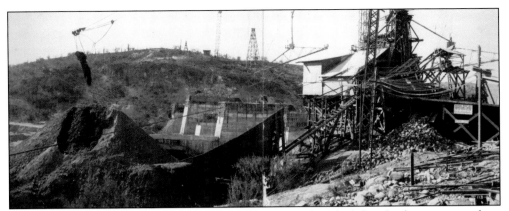

A photograph from 1926 shows the exterior of the cement plant (right) with a buttress rising from the riverbed (left). The tower rising in front of the cement plant was a placement tower where mixed concrete was ferried in a large hopper to various locations on the dam site. (Courtesy of the Library of Congress, HAER ARIZ, 7-PHEN.V, 5-11.)

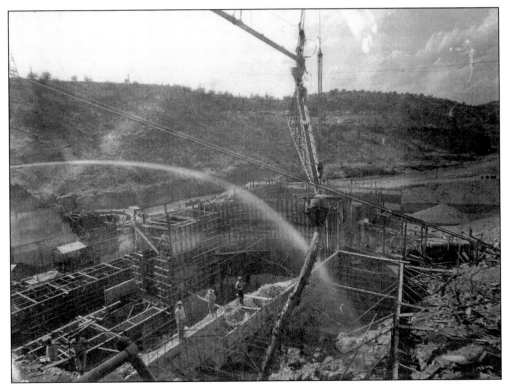

From the placement tower, mixed concrete was poured through chute lines and gravity fed into the forms as can be seen in this 1926 photograph. (Courtesy of the U.S. Bureau of Reclamation.)

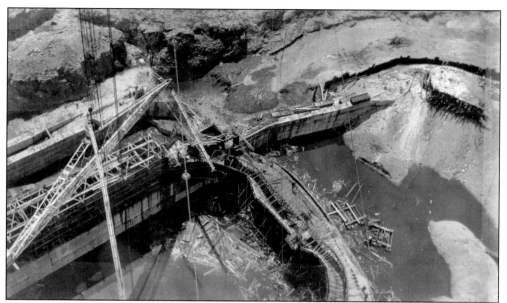

The view here is from a placement tower in 1926. From this dizzying height, it is easy to imagine the dangers of working on the Pleasant Dam. One person is known to have fallen from the dam. He lived. Only one person was reported to have died, in a gruesome accident involving igniting a barrel of gasoline. (Courtesy of the Library of Congress, HAER ARIZ, 7-PHEN.V, 5-14.)

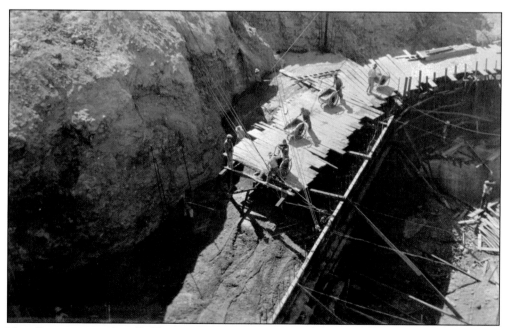

Not all concrete was handled by machinery. This photograph dated July 1926 shows men doing it the old-fashioned way, hauling concrete up ramps and dumping it. Temperatures in the Arizona desert regularly exceed 110 degrees in summer, and there were no air-conditioned spaces to escape to in 1926. (Courtesy of the Library of Congress, HAER ARIZ, 7-PHEN.V, 5-13.)

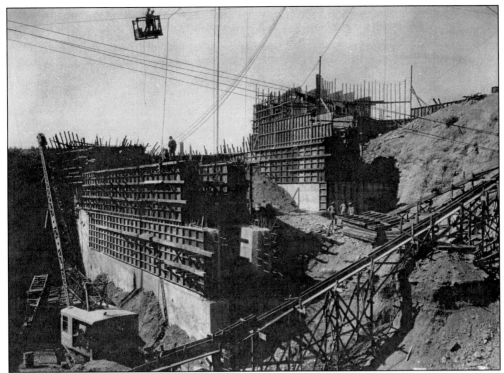

Concrete was poured in stages. This 1926 photograph shows the buttress forms rising to the top of the west abutment. The efficient layout and organization of Camp Pleasant enabled work to proceed rapidly. Carl Pleasant managed to pour 8,000 cubic yards of cement a month. Note the cableway overhead, used to move men and equipment rapidly across the construction site. (Courtesy of the U.S. Bureau of Reclamation.)

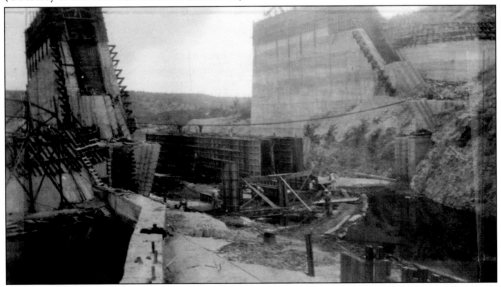

This photograph shows a newly poured buttress in a 1927 upstream view. A nearly complete arch can be seen at right and the beginnings of another at center. (Courtesy of the Library of Congress, HAER ARIZ, 7-PHEN.V, 5-23.)

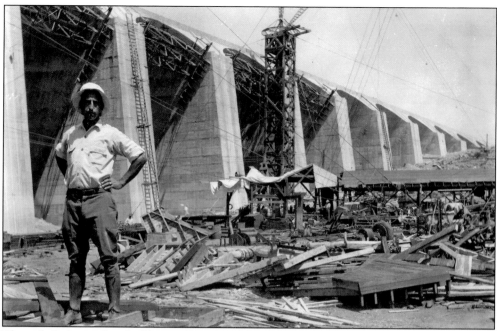

The arch design used in the Pleasant Dam was a thin-arched, inclined barrel. It causes the reservoir pressure to concentrate on the crown of the barrels and distribute the force through the buttresses and foundation. This allowed for a much lighter structure with much less foundation contact than gravity dams. Moreover, the arch design made these dams less likely than gravity dams to slide on their foundations. Multiple-arch dams, though a relatively new design at the time, were hailed by some as "the ultimate dam design." Though requiring fewer materials, they did require more intensive labor. The concrete had to be reinforced with steel, as can be seen in these 1927 photographs of arch construction. (Above, courtesy of the Salt River Project; below, courtesy of the U.S. Bureau of Reclamation.)

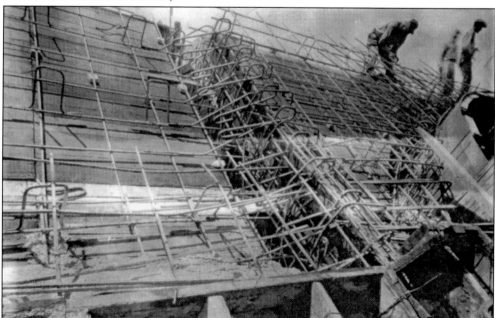

In January 1927, Robert Beardsley (right, wearing the vest) and an unidentified man survey the Pleasant Dam as it progresses from both east and west toward the middle. Camp Pleasant is visible on the hill in the background. (Courtesy of the Salt River Project.)

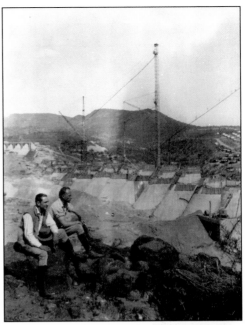

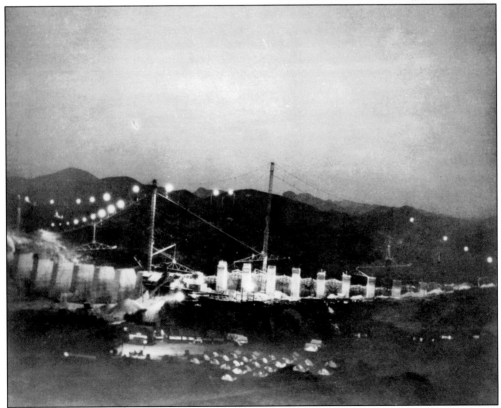

A downstream view of the camp and dam site is shown as work goes on into the night from 1927. Construction proceeded rapidly, as the dam was completed in less than two years. (Courtesy of the Library of Congress, HAER ARIZ, 7-PHEN.V, 5-27.)

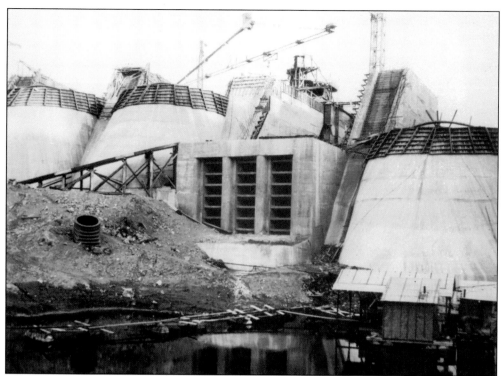

The penstock openings installed between buttress no. 9 and no. 10 are pictured in 1927. This upstream view shows three openings, one for each penstock, that allowed for normal water releases. Placement towers and chute lines can be seen above the rising arches. (Courtesy of the Library of Congress, HAER ARIZ, 7-PHEN.V, 5-24.)

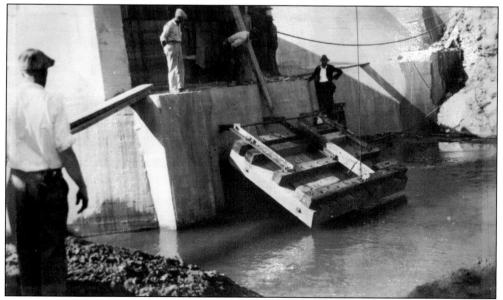

A photograph, taken in 1927, shows a temporary gate that was placed over a penstock opening on the upstream side to control water flow. (Courtesy of the Library of Congress, HAER ARIZ, 7-PHEN.V, 5-32.)

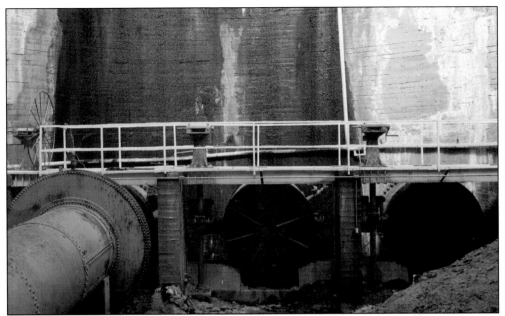

Three penstock openings on the downstream dam base are shown around 1927. A 72-inch outlet pipe is connected on the left. The operating wheel just above it opened a butterfly valve that would feed the lower lake, created by the Camp Dyer Diversion Dam to supply irrigation water to the Beardsley Canal. The other two outlets, intended for electric generators, were never used. (Courtesy of the Library of Congress, HAER ARIZ, 7-PHEN.V, 5-68.)

In about 1927, this interior view was taken of the penstock housing and the motor used to operate a 54-inch needle valve that controls flow. (Courtesy of the Library of Congress, HAER ARIZ, 7 PHEN.V, 567.)

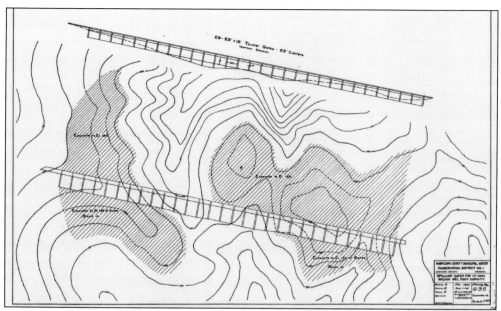

From 1925 are plans for the spillway, just northwest of the dam. These plans state a capacity of 150,000 cubic feet of water per second. The actual capacity would turn out to be lower. (Courtesy of the Library of Congress, HAER ARIZ, 7-PHEN.V, 5-135.)

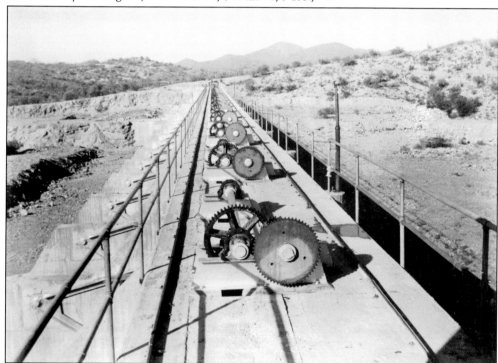

A photograph taken at the top of the Pleasant Dam spillway in 1927 shows the operating gears for the 29 tainter gates. The mechanisms could be operated by hand as well as a motor. Water would be released at 154 feet above the riverbed. (Courtesy of the Library of Congress, HAER ARIZ, 7-PHEN.V, 5-34.)

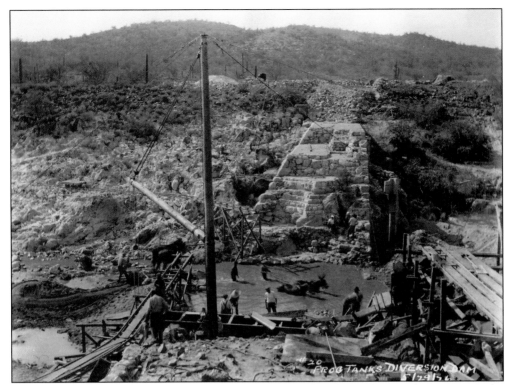

Work resumed on completion of the Camp Dyer Diversion Dam around 1926. The gap seen in the photograph is the portion on the west end that was swept away during the flood of 1895. Rather than completing it by continuing the block masonry work, concrete was poured. (Courtesy of the Salt River Project.)

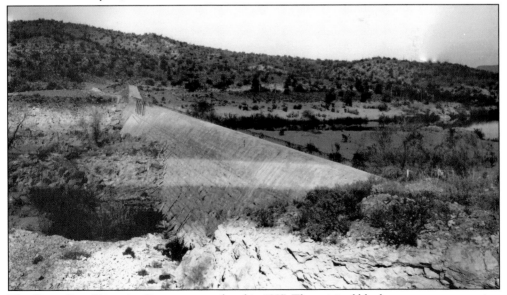

The Camp Dyer Diversion Dam was completed in 1927. The original block masonry construction can be seen on the lower part of the structure. Concrete can be seen on the top as well as the gap on the west side (left center). (Courtesy of the Salt River Project.)

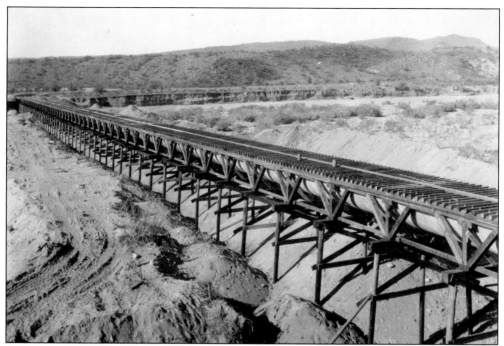

The original Beardsley Canal Flume, which brought water from the east to the west bank of the Agua Fria River, is pictured around 1927. The MWD service area lies west of the river. (Courtesy of the Library of Congress, HAER ARIZ, 7-PHEN.V, 5-43.)

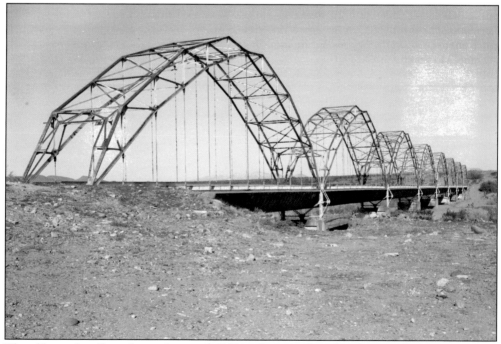

The old wooden flume burned around 1950 and was replaced with a sturdier, fireproof, all-steel structure, shown here around 1986. (Courtesy of the Library of Congress, HAER ARIZ, 7-PHEN.V, 5-75.)

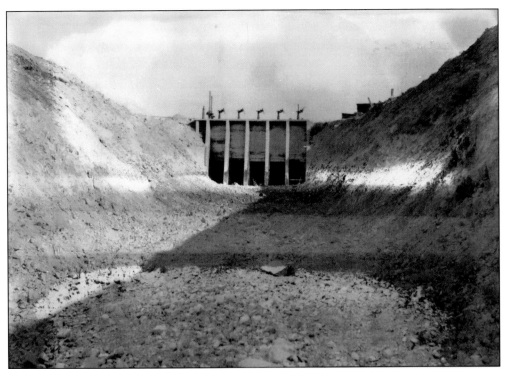

This photograph was taken downstream, looking at the face of the head gates inside the Beardsley Canal, just after they were completed in 1927. Unfortunately, the MWD would have to wait several more years to use them because of the controversy over the buttress cracks. (Courtesy of the Salt River Project.)

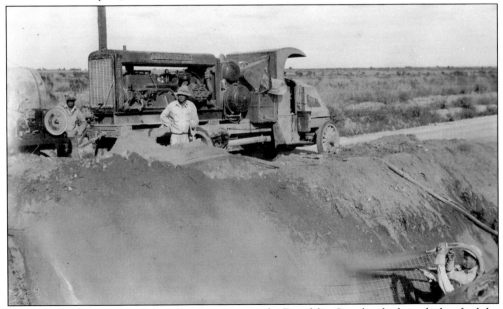

The ultimate destination of the Agua Fria water in the Beardsley Canal is the laterals that feed the turnouts and water customers' fields. The canal and laterals were lined with gunite (cement applied with pneumatic pressure), as seen here around 1935. (Courtesy of Maricopa Water District.)

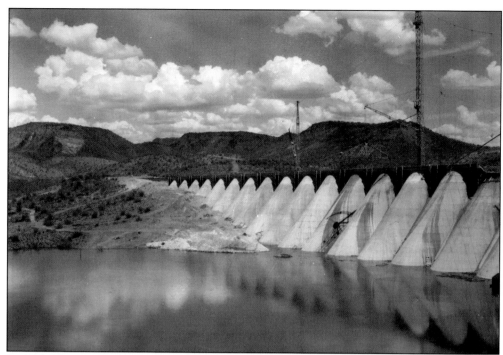

In 1927, Pleasant Dam nears completion as Lake Pleasant begins to fill. The crest of the dam, seen in these photographs, was atypical of multiple-arch dams being built at the time. The tops of the arches were customarily extended to the top of the buttresses, then cut off on a horizontal plane at the crest. The Pleasant Dam crest was finished with a 2-foot, vertical-face slab at the crest. This was done as a cost-saving measure as less material was needed. It was a measure that would later haunt the project by giving critics more ammunition with which to question the dam's safety. (Above, courtesy of Phoenix Public Library; below, courtesy of the Library of Congress, HAER ARIZ, 7-PHEN.V, 5-35.)

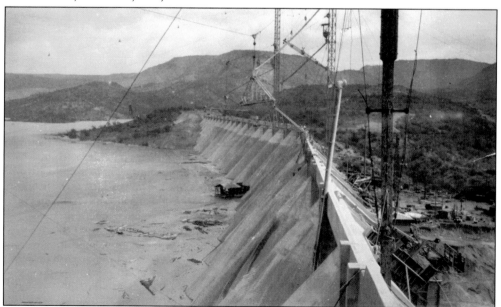

# *Four*

# THE CRACKS

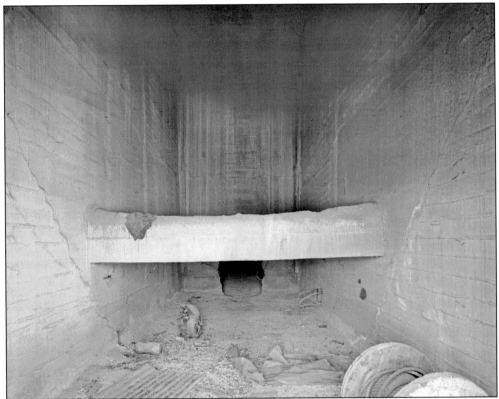

As the Pleasant Dam neared completion in October 1927, preparations were being made to dedicate the world's tallest multiple-arch dam. Actress Gloria Swanson was invited to christen it with a bottle of grapefruit juice. These plans were put on hold as Robert Beardsley, Donald Waddell, and Carl Pleasant became aware of a problem endangering the entire enterprise: cracks had formed in the concrete buttresses. In this photograph (1988), cracks (though filled) can be seen on both walls extending down, at about a 45-degree angle, to the buttress tie in the center. Concerned, Carl Pleasant asked three engineers for their opinion. Fred A. Noetzli, a leading authority on dams, criticized the project for not extending the arches to the tops of the buttresses. William Davenport of the Santa Fe Railroad, who approved the dam's plans, was not concerned about the cracks. Finally, Bernhard Jakobsen, who examined a similar problem on Lake Hodges in California determined the Pleasant to be "less safe" than that one but couldn't say how much so. (Courtesy of the Library of Congress, HAER ARIZ, 7-PHEN.V, 5-66.)

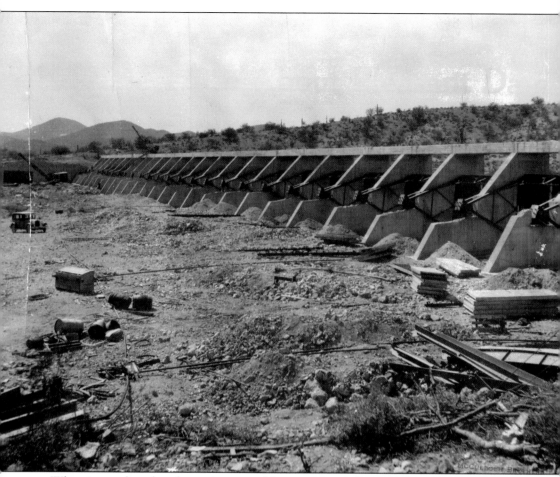

When it was clear that the engineers could not agree on what to make of the cracks, the State Certification Committee, which had previously approved the dam plans, hired three of their own engineers to reevaluate the Pleasant Dam. They determined the cracks to be unsafe and proposed filling and reinforcing them. They also suggested the Pleasant Dam spillway, already the largest of any dam in the state, was inadequate. Since the dam had already held water to 117 feet deep, they determined that was a safe level but conceded that 130 feet was "probably safe." They recommended that yet another spillway be built west of the present one. It was decided to keep the water level at 130, even though the dam's single penstock could not be relied on to achieve this. Above, in 1927, the downstream side of the Pleasant Dam spillway was first calculated to have a capacity of 105,000 cubic feet per second, which matched the greatest recorded river flow to that time. It was later recalculated to 117,000 cubic feet per second. (Courtesy of the Library of Congress, HAER ARIZ, 7-PHEN.V, 5-33.)

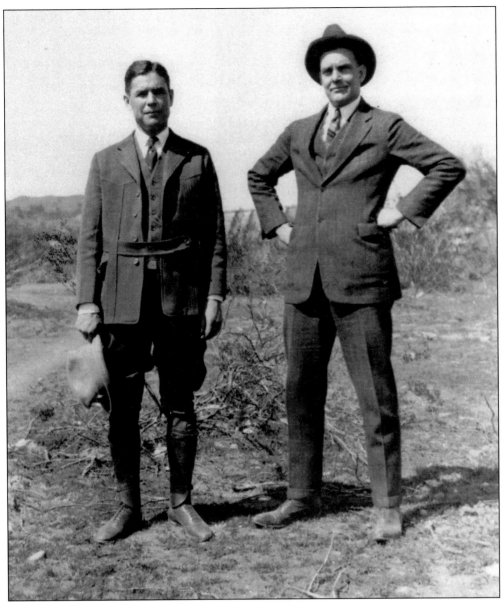

Two persons with no difficulty agreeing what to do with the Pleasant Dam were Frank Reid (left) and Charles C. Cragin (right), the president and general superintendent of the Salt River Valley Water Users Association. They regarded the MWD as a challenge to the authority of the federally funded Salt River Project. By 1929, two years of conflicting reports had done nothing to resolve the controversy surrounding the Pleasant Dam cracks. Under the pretence of genuine discussion of the issues, Reid and Cragin convened a meeting of the Maricopa County Board of Supervisors and intended to have the dam condemned. Carl Pleasant vigorously defended his dam, pointing out that it had to endure less than half the stresses experienced at the Users Association's own multiple arches on the Cave Creek Dam. He further noted the cracks at Pleasant Dam were the result of temperature, forming prior to significant accumulation of water in Lake Pleasant. Cragin countered that if the Pleasant Dam overtopped, "it is gone," in spite of the fact that multiple-arch dams had regularly survived overtopping. (Courtesy of the Salt River Project.)

*April 1, 1929.*     THE ARIZONA PRODUCER     *Page T..*

# Jnpleasant Truth About Pleasant Dam

## *State Is Spending Huge Sum to Remove Menace Hanging Over Thousands of Lives and M.. lions of Dollars Worth of Property*

... of Arizona suffering a flood beside which the San Francis-
...aster in California would be a trifling matter, is fast being
... by the process of removing the west end of the spillway at
...nt dam and excavating a wide channel down to a depth where
... above 130 feet will be impossible.

...ork is being done with funds appropriated by the State Legis-
... years after the builder of the dam had been told by his own
...that it was faulty in design and in a dangerous condition.
...te officials have been cognizant of the situation since January,
...the directors of Maricopa Municipal Water Conservation Dis-
...ust have known of it for at least that long.

... hours of flood in the Agua Fria River and the dam would
... danger of giving way. A head of 1,500,000 second feet
... swept down that stream from Frog Tanks, snuffed out thou-
...res, inundated at least 50,000 acres of the Salt River project,
... Buckeye, Arlington and Gillespie districts, drowned out the
...sa and much of that valley, torn away the headgates and dikes
...erial canal system, and probably poured into the Salton Sea.

... guesswork but the sober
...nse of the most eminent
...he United States, as well as
...omen not so well known but
...ding in their profession.
...han 20 reputable engineers
...refully examined the Lake
..., not one would put his sig-
...ature pronouncing it safe.

**Villain of the Piece**

...he man who was first to in-
...mething be done to remove
... to lives and property, wh...
...movement to have the leg-
...an emergency appropriation
... what the Maricopa Munici-
...onservation District had no
...pparently no disposition—to
...subjected to a campaign of
...abuse and misrepresentation
...t parallel in the annals of

... charged that this man is
... grab the water of the
...ject for the Salt River Val-
... Association. It has been...
...took office. He stated he was in doubt
...as to what steps he could take under

was unsafe for storage above 130 feet.

### An Order—But What of It?

On December 29 the state water com-
missioner ordered the district not to im-
pound water above 130 feet. But there
was no way he could enforce his order.
The spillway, built across a shallow can-
yon a hundred yards west of the dam,
was too high to relieve the pressure. The
relief gates in the dam itself were too
small.

For the district to ignore the water
commissioner's order would have consti-
tuted, under the state law, a misdemeanor
punishable by a fine of $300!

How they were to avoid storing water
above the danger line, in case of heavy
rains on the watershed above, has never
been explained. There simply was no
way for the water to get out. And se-
vere winter storms might be expected any
day, as weather bureau records attested.

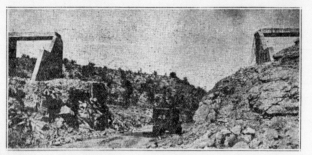

—Producer Staff Photo

**Fifty-foot cut through Pleasant dam spillway, showing one of three steam shovels on
job. This cut will be widened to 175 feet.**

An appeal was made to the Eighth
State Legislature to make an appropria-

...ous flood. A Los Angeles contra...
recommended by the Santa Fe has ...
steam shovels clearing a great ...
that will carry off all water bro...
down by the Agua Fria without me...
to those living below.

The ditch is 50 feet wide now.
Friday, March 22, the state board
trusted with overseeing the expenditu...
the appropriation, decided that the e...
gency is so grave as to warrant enlar...
the trench to the width of 175 feet ...
gested by so many engineers. A fo...
order for that enlargement was the...
sued.

### Those Vertical Cracks

Now, to get down to what the engin...
actually reported on Carl Pleasant d...
Noetzli found:

"Most of the buttresses had devel...
vertical cracks extending from the
face of the ground to some dista...
above, in most cases extending all...
through the whole height of the butt...
as constructed at that time. It is q...
likely that not all the existing cr...
could be detected. Furthermore, eve...
no cracks had occurred in the buttre...
at the time of my inspection, and ...
though they were far apart in those
tresses in which the cracks could pla...
be seen, it is quite likely that consi...
able tension stresses existed in the ...
tresses in a horizontal direction from
shrinkage of the concrete."

Noetzli wrote further:

"My inspection of the dam an...
the seriousness of the situation a...
revealed thereby prompt me to re...
ommend some emergency measure...
which were submitted to Mr. Trip...
by memorandum dated February 13...

But Noetzli's recommendations w...
not followed. Neither were those of
kobsen, who went exhaustively into ...
culations of stresses and strains, ...
wrote on January 17, 1928:

"I wish I could have come to a differ...

---

Reid used his influence to form an engineering board that would work with the state water
commissioner, Frank P. Trott, to determine the dam's fate. Reid was voted chairman of that board.
He used his considerable political influence to convene a special session of the state legislature to
look into the dam's safety. As before, numerous experts were consulted, but no two could agree
on what level of danger the dam posed, if any. Reid and Cragin also used the Users Association
house organ, the *Arizona Producer*, to spread fear over the dam's safety within a self-serving report,
featuring alarming headlines, about the "menace" to thousands of people and millions in property
loss. It also attacked Robert Beardsley and Carl Pleasant while refuting charges that Reid owned
land downstream of the MWD and stood to benefit from the project's demise. Reid did in fact
own the land. (Courtesy of the Salt River Project.)

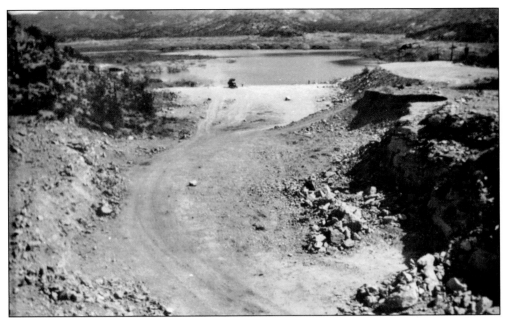

While Frank Reid constantly manipulated the uncertainty surrounding the relatively new technology of multiple-arch dams, another event caused more anxiety over the safety of the Pleasant Dam. On March 12, 1928, the St. Francis Dam in California suffered a catastrophic failure. Regardless of the fact that it was a gravity dam, not a multiple-arch design, public anxiety over the safety of the Pleasant Dam grew. These things compelled Commissioner Trott to take action. In January 1929, based on recommendations from the board Reid chaired, it was decided that the Pleasant Dam spillway would be lower by 24 feet. The photograph above shows the cut made to lower the spillway level. Below is the 50-foot-wide section of the spillway removed to accommodate the cut. (Both courtesy of the Library of Congress; above, HAER ARIZ, 7-PHEN.V, 5-42; below, HAER ARIZ, 7-PHEN.V, 5-41.)

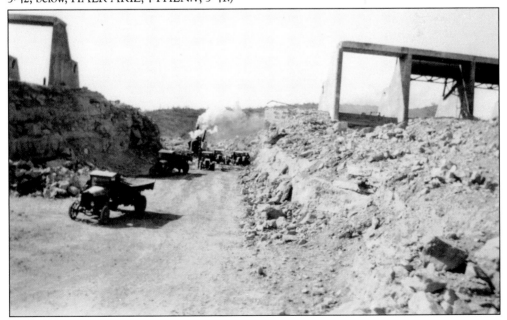

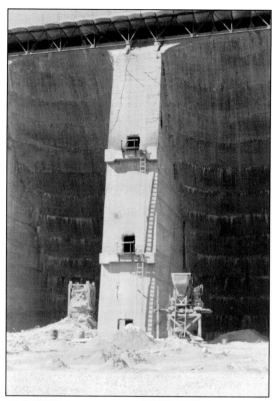

Spillway modifications rendered Lake Pleasant too low to deliver irrigation. Added to the costly Southwest Cotton litigation, the MWD went bankrupt again. Carl Pleasant suddenly died in 1930, leaving Robert Beardsley and Donald Waddell to solve the buttress problem. The future looked bleak. Help came from a former antagonist: the federal government. The MWD reorganized under the Reconstruction Finance Corporation (RFC), under the Hoover administration. After refinancing for $4.5 million, the MWD moved forward with infrastructure repairs and improvements. These 1935 photographs show access holes in the hollow buttresses, which were used to place reinforced concrete. At this time, a new steel roadway was added and can be seen on the top of the dam. An addition was added to the water slab, and the cracks were pressure grouted. (Both, courtesy of the Library of Congress; above, HAER ARIZ, 7-PHEN.V, 5-44; below, HAER ARIZ, 7-PHEN.V, 5-46.)

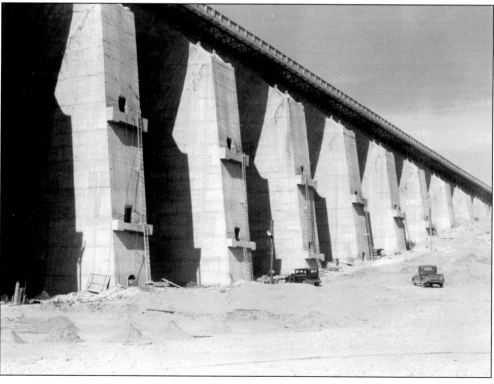

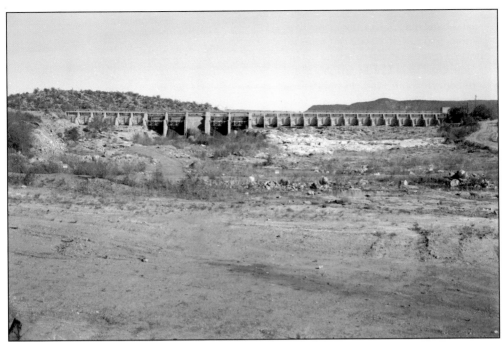

The improvements of 1935 were done by Carl Pleasant's brother, Joe Pleasant. The 50-foot gap taken from the spillway was replaced with four tainter gates and a sector gate, which can be seen in these c. 1988 photographs. Other work included improvements to the canal along with the addition of 47 groundwater pumps to supplement water supplies during droughts—like the one that plagued the project beginning in 1930. The drought ended when the lake received more the 100,000 acre-feet of water in 1936. Though they were not around to see it, the dream of William Beardsley and the work of Carl Pleasant were done. (Both courtesy of the Library of Congress; above, HAER ARIZ, 7-PHEN.V, 5-70; below, HAER ARIZ, 7-PHEN.V, 5-71.)

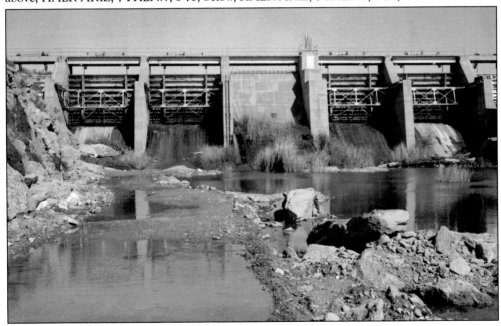

It took 40 years to complete. Unknown to many living near it, Lake Pleasant is actually named after a man who helped create it rather than the promise of a leisurely day. After 1964, the dam would be known as the Waddell Dam and, finally, the Old Waddell Dam, which now rests under a new Lake Pleasant. As for William H. Beardsley, the place known as Beardsley is long gone. Few know of the Beardsley Canal that crosses the lonely desert. Most people in the Phoenix metropolitan area don't even know his name. But his life's work (seen here around 1988) helps make it possible for them to live there. Regardless, the snow-covered Bradshaw Mountains, in the background, promise more water for this man-made creation. (Courtesy of the Library of Congress, HAER ARIZ, 7-PHEN.V, 5-62.)

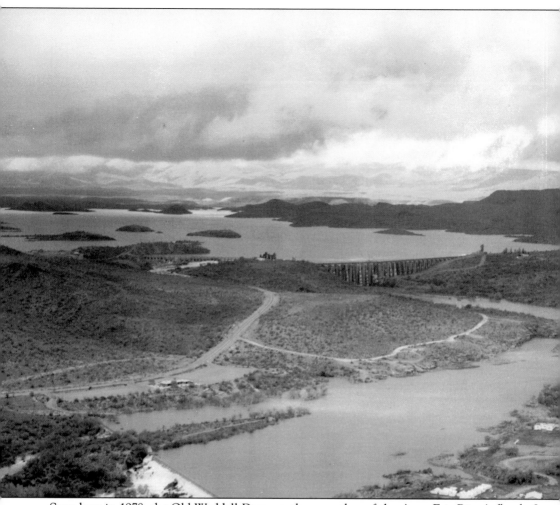

Seen here in 1978, the Old Waddell Dam weathers another of the Agua Fria River's floods. It stood for 65 years without any safety issues. Whether the improvements made on it in 1935 were necessary or not will be forever obscured by the fog of the politics of water in the West. (Courtesy of Lake Pleasant Regional Park.)

# *Five*

# RIVERS FLOW UPHILL

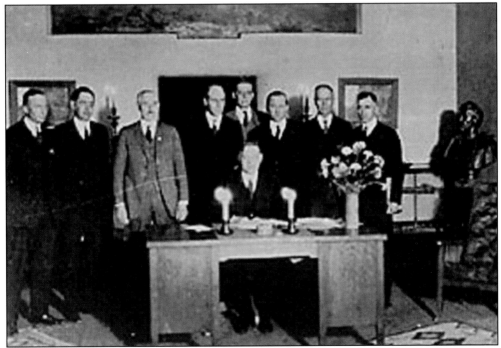

At Bishop's Lodge, New Mexico, in 1922, Secretary of Commerce and future president Herbert Hoover presides over the Colorado River Compact, an agreement signed on to by seven states: Arizona, California, Colorado, Nevada, New Mexico, Utah, and Wyoming. It was the beginning of a series of agreements and legislation that came to be known as the Law of the River. It determined how the Colorado River would be utilized and what amounts each state (and later Mexico) would receive. The Arizona Legislature was dissatisfied over the state's allotment (less than 1 percent of the total) and didn't ratify the agreement until 1944. Nevertheless, the ultimate fate of the Waddell Dam and Lake Pleasant was set in motion by forces of an agreement made five years before the dam was built. (Courtesy of the U.S. Bureau of Reclamation.)

After ratifying the Colorado River Compact, Arizona immediately began planning how it would deliver millions of acre-feet of water to Central and Southern Arizona. Senators Carl Hayden (left, around 1932) and Ernest McFarland (below, around 1941) began efforts to authorize the Central Arizona Project (CAP). However, Arizona still disputed the allocation of water, which wasn't settled until the U.S. Supreme Court ruled in Arizona's favor on the allotments in 1964. Not until 1968 was CAP legislation, supported by Arizona senators Carl Hayden and Paul Fannin, signed into law by Pres. Lyndon Johnson. Construction began in 1973. (Left, courtesy of the Library of Congress, LC-USZ62-107893; below, courtesy of the Senate Historical Office.)

Built by the Bureau of Reclamation and operated by the Central Arizona Water Conservation District, the CAP is often simply thought of as a long canal. In modern engineering terms, it is more accurately called an aqueduct—a water conveyance system, which in the case of the CAP includes canals, pumping plants, siphons, reservoirs, dams, and tunnels. The system (actually three aqueducts) is tasked with lifting 1.5 million acre-feet of Colorado River water 2,900 feet across 336 miles of desert. Seen above around 2004 is a segment of the 190-mile-long Hayden-Rhodes Aqueduct. Below is the canal lining around 1977, part of the $4-billion CAP. This segment in North Phoenix is simply known as "Reach 11." Water depth in the canal averages between 10 and 23 feet. (Both, courtesy of the U.S. Bureau of Reclamation.)

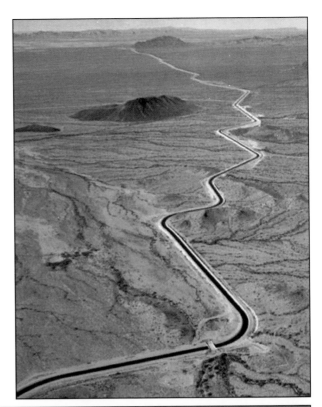

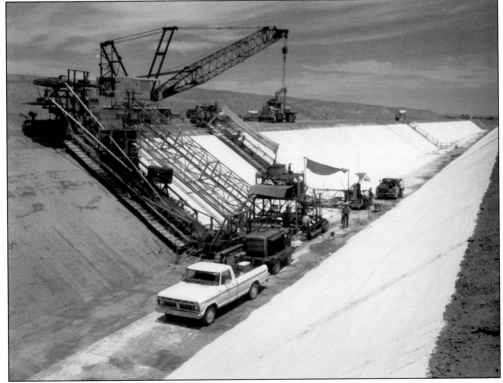

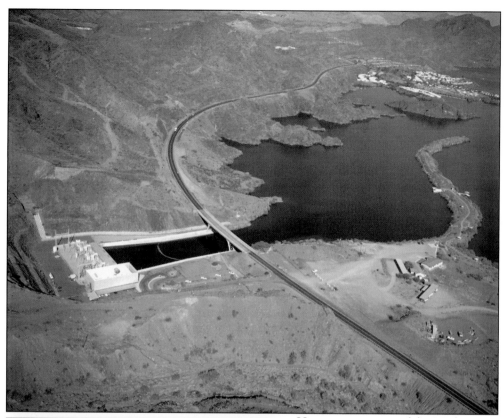

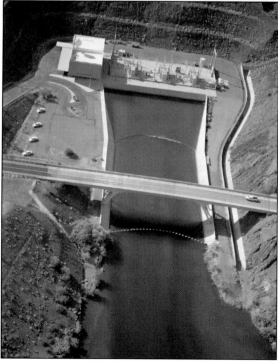

Here are two views of the Mark Wilmer Pumping Station on Lake Havasu, the first of 15 pumping stations on the project and the first contract awarded for the CAP in 1973. It pushes water up and through the 22-foot-diameter Buckskin Mountain Tunnel for almost 7 miles. A diversion dike (above, right) is not unlike a giant version of the weirs the Hohokam used to put out in rivers to divert water into their canals. Arizona State Highway 95 (left) crosses the pump house intake channel. Mark Wilmer was an attorney largely responsible for Arizona's Colorado River water allotment victory in *Arizona v. California*, 1964. (Both, courtesy of the U.S. Bureau of Reclamation.)

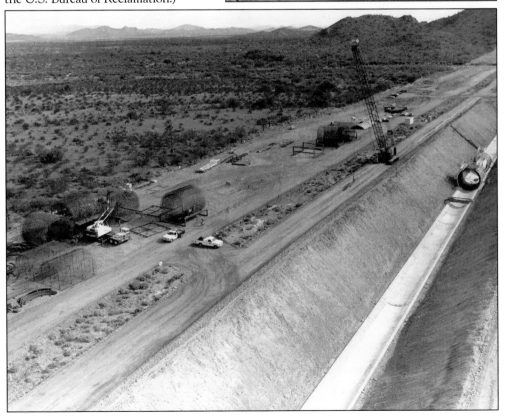

When natural rivers had to be crossed by the CAP aqueduct canals, a siphon was constructed. In engineering terms, this is a tube that transfers liquid from one level to another using atmospheric pressure. The opposite of the flume, siphons convey water under rivers instead of over. These photographs from 1994 show construction being done on the New River Siphon, just north of Phoenix. (Both, courtesy of the U.S. Bureau of Reclamation.)

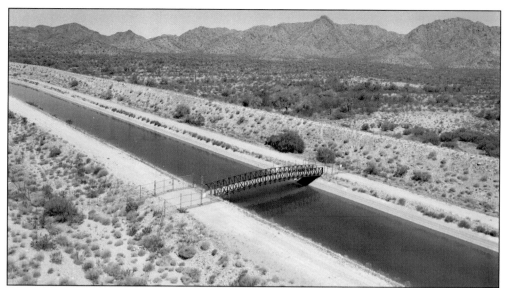

In addition to siphons taking CAP water under rivers, there are bridges across the aqueducts. As these undated photographs show, not all bridges are for humans. Wildlife crossings were not the only environmental considerations shaping the CAP and, ultimately, Lake Pleasant. The original plan for Central Arizona called for water storage behind the proposed Orme Dam at the confluence of the Salt and Verde Rivers. However, the often displaced Yavapai won a rare victory in 1981, stopping the dam and saving their Fort McDowell home, largely based on environmental impact. During the 19th century, nature was a force to be overcome. Such considerations were not always part of the mind-set of those who created Lake Pleasant. Now they would help shape the next Lake Pleasant. (Both, courtesy of the U.S. Bureau of Reclamation.)

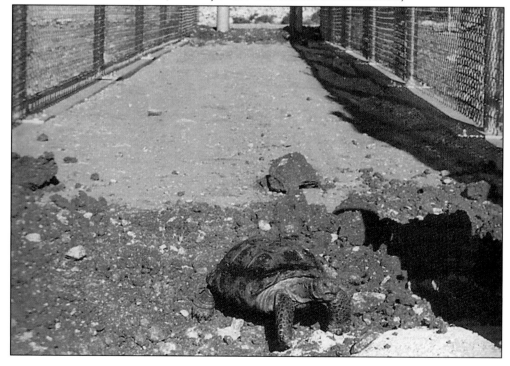

# *Six*

# THE NEW WORLD

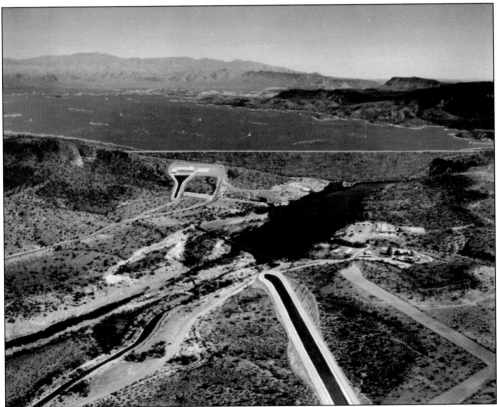

When the Orme Dam was defeated, a new storage reservoir had to be selected to hold Colorado River water delivered by the CAP aqueduct. Eight alternative plans were considered. Plan 6, which included the enlargement of Lake Pleasant behind a new dam, was adopted in 1984. This photograph from 1985 demonstrates the remarkable leaps in technology that had taken place in the 58 years since the Old Waddell Dam was raised. The new dam, Hank Raymond Lake (center), pump/generating plant (left side below dam), the lake itself, even the boats on the main lake, all seen here, did not exist in 1985. Engineers constructed a "virtual" project using computer-enhanced images overlaid on the dam site. The New Waddell Dam and reservoir would be nearly triple the size of the existing one. The large canal extending down from the center (also computer-generated) would be the Waddell Canal, which can ferry water about 5 miles upstream or down to or from the CAP aqueduct. (Courtesy of the U.S. Bureau of Reclamation.)

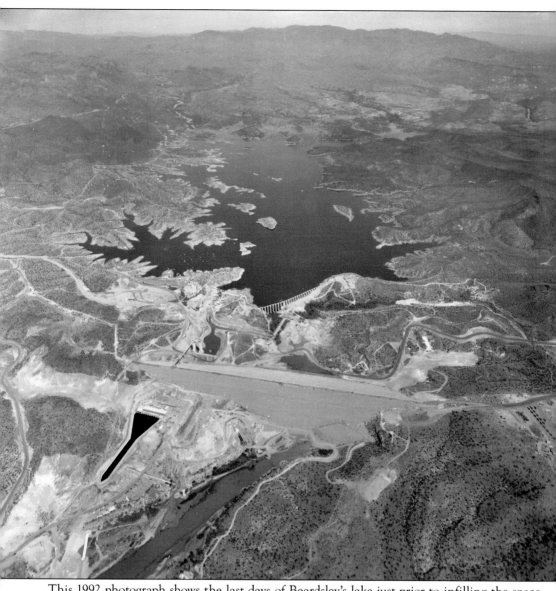

This 1992 photograph shows the last days of Beardsley's lake just prior to infilling the space between the old and new dams. Old Waddell Dam's structural height is 174 feet, the crest length is 1,800 feet, and the maximum surface area is 3,700 acres. There is no pump or generating capacity. (Courtesy of the U.S. Bureau of Reclamation.)

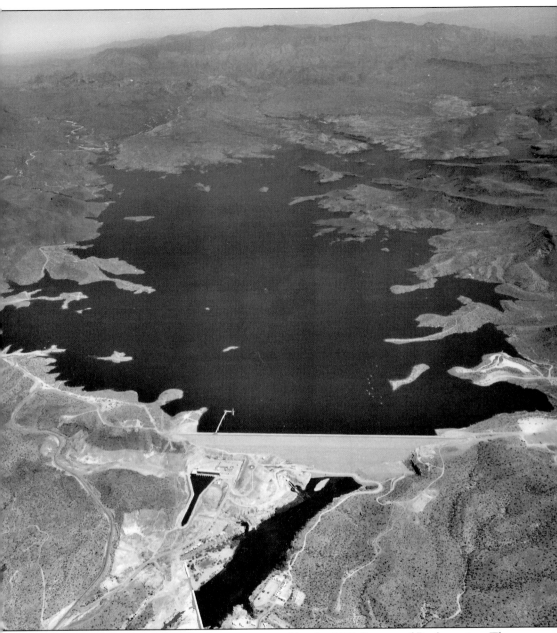

Here in 1993 is the new Lake Pleasant constructed by the U.S. Bureau of Reclamation. The primary contractor was Ebasco. The New Waddell Dam's structural height is 440 feet, the crest length is 4,900 feet, and the maximum surface area is 9,970 acres. It has four pumps and four generators. (Courtesy of the U.S. Bureau of Reclamation.)

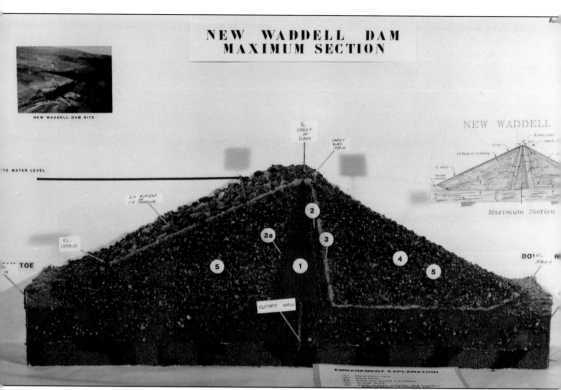

# NEW WADDELL DAM
## MAXIMUM SECTION

Engineers worked up this cross-section model of the New Waddell Dam in 1986. Like the Old Waddell Dam, cost saving was a major consideration. The similarities end there. The "zoned" earthen dam design selected was a massive, prism-shaped, man-made mountain of earth and rock. On the left is the upstream side. The black line represents maximum water level. Zone 1 is a compacted clay core, impervious to water. This is the key element of an earthen dam. Zone 2 is a sand filter. Zone 2a is a sand and gravel transition layer. These are designed to preserve the integrity of the core. Zone 3 is a gravel drain to remove seep water. Zones 4 and 5 consist of cobble and boulders to add mass, form a shell, and stabilize the clay core. Large boulders called "riprap" cover the upstream face to shield against wave action. Deep inside, underneath the core, a concrete "cutoff wall" is inserted into the bedrock, preventing seepage through the foundation. (Courtesy of the U.S. Bureau of Reclamation.)

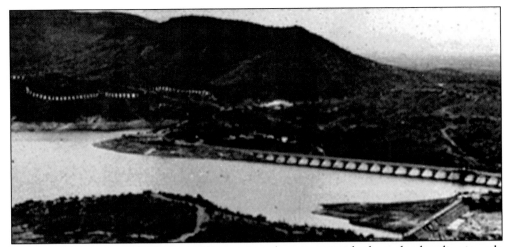

In this c. 1986 photograph, the dotted line seen on the mountainside above the shoreline is made up of markers placed by surveyors indicating where the new shoreline would be located after Lake Pleasant filled behind the New Waddell Dam. (Courtesy of Lake Pleasant Regional Park.)

Attempts to salvage native cacti were conducted in areas that would be inundated by the rising waters of Lake Pleasant. In this 1990 photograph, volunteers do their best to save as many plants as possible. (Courtesy of the U.S. Bureau of Reclamation.)

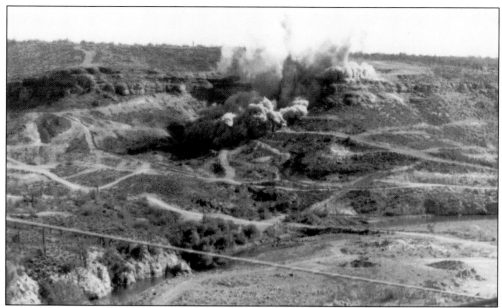

Preparation of the dam site began in 1987. While some blasting (as seen above) was done to prepare the foundation, it was kept to a minimum in order to preserve the integrity of the underlying rock. (Courtesy of Maricopa Water District.)

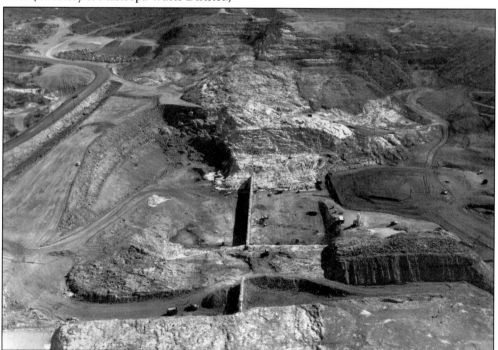

Foundation preparations included placement of seepage barriers, called cutoff walls, in the bedrock. This view from 1990 shows the dam foundation and cutoff walls from the west abutment. The subcontractor that installed the wall was a French-based company. The French construction crew was dismayed when they learned that drinking wine on lunch breaks was prohibited on U.S. Bureau of Reclamation job sites. (Courtesy of the U.S. Bureau of Reclamation.)

In 1990, heavy equipment is at work on the foundation and embankment with the cutoff wall in the background. (Courtesy of the U.S. Bureau of Reclamation.)

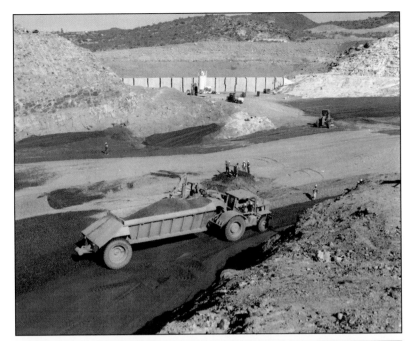

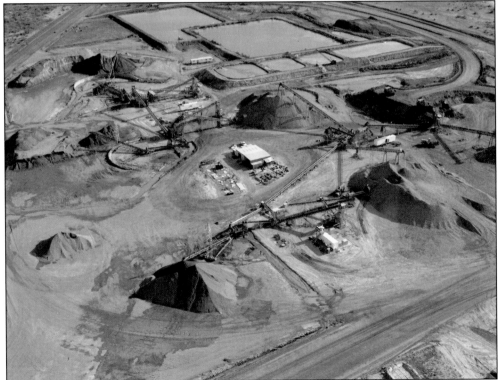

Vast amounts of materials were required to construct the New Waddell Dam. Most of it was excavated and processed from the New River Borrow (seen here in 1992), along the Agua Fria's largest tributary, and hauled to the worksite in huge dump trucks. (Courtesy of the U.S. Bureau of Reclamation.)

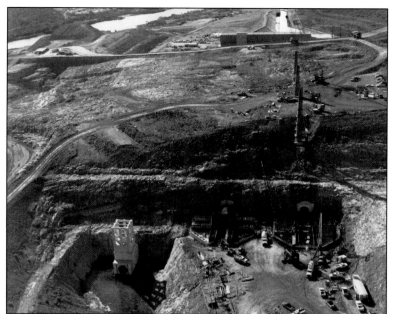

Three penstocks were required for the dam. Seen here from the upstream side in 1990 are the river outlet (left) and the two outlets (right) for the pump/generator plant, which can pump water in or out of the dam. The pump/generator plant can be seen under construction at top right. (Courtesy of the U.S. Bureau of Reclamation.)

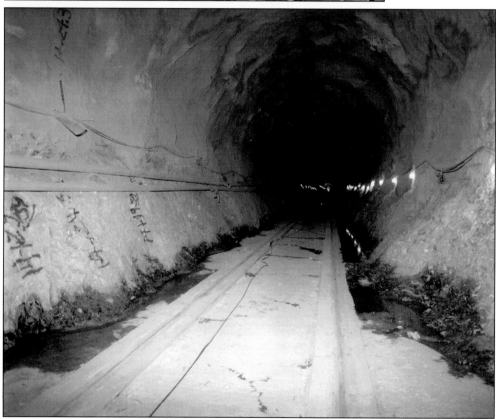

The tunnel bore through the dam's base for the river outlet. The river outlet diverted the river from the site during construction and would help regulate water storage behind the new dam. (Courtesy of the U.S. Bureau of Reclamation.)

Above in 1990, giant, removable forms called liners were used to shape the river outlet and pump/generator penstocks. Below, a liner is positioned with the aid of giant crane. (Courtesy of the U.S. Bureau of Reclamation.)

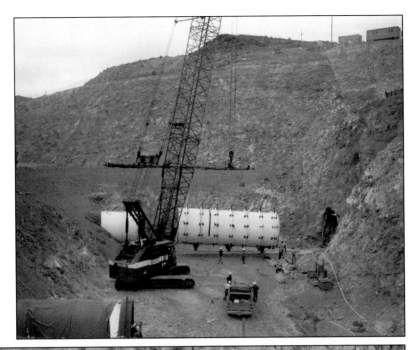

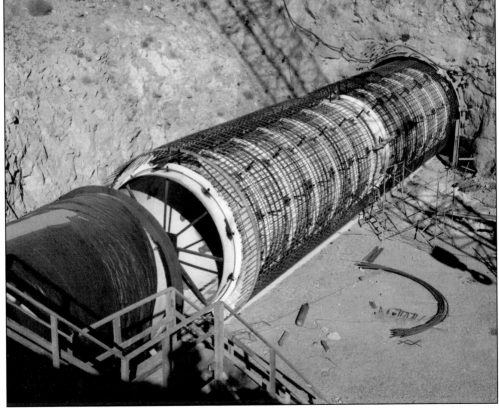

In 1990, reinforcement is placed around the form before insertion into the bore. The prepared form was slid into the bore on rails with great precision. (Courtesy of the U.S. Bureau of Reclamation.)

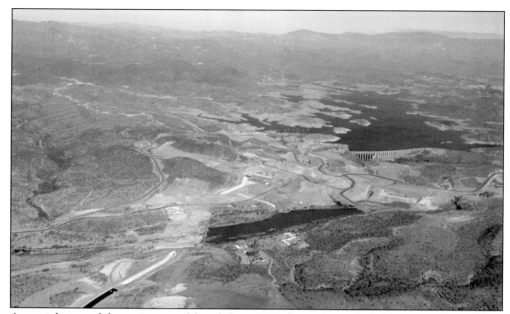

An aerial view of the project site (above) from 1990 shows the end of the 5-mile-long Waddell Canal (lower left) terminating at a siphon underneath the Agua Fria and connecting with the inlet for the pump/generating plant (the Y-shaped concrete patch in the center). Colorado River Water for Central Arizona is pumped behind the dam for storage and is available for use. The plant generates electricity during peak demand time and sells it to offset the CAP construction costs. Below is the pump generating plant under construction. (Both, courtesy of the U.S. Bureau of Reclamation.)

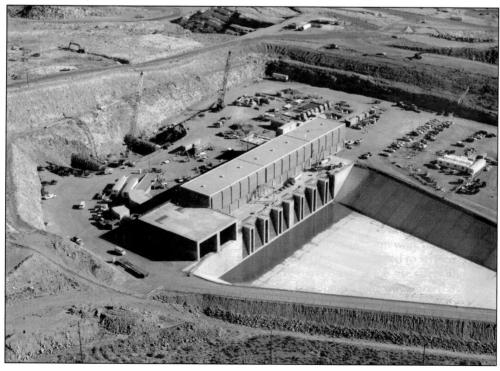

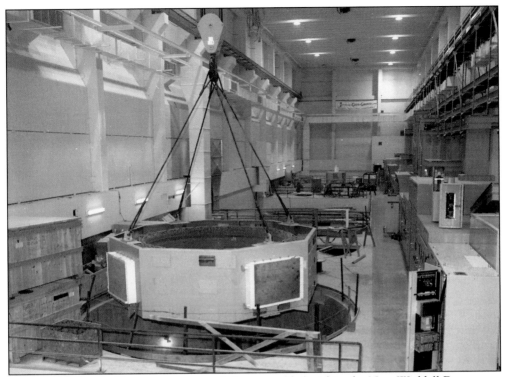

Here in 1992, one of four generators are being assembled within the New Waddell Dam pump generating plant. The plant is capable of generating 45 megawatts at peak power. (Courtesy of the U.S. Bureau of Reclamation.)

In 1990, the foundations of the two large intake towers stood in Lake Pleasant on the upstream side of the dam. They will be attached to the pump/generator penstocks, which can be seen behind the tower foundation protruding from the rock. (Courtesy of the U.S. Bureau of Reclamation.)

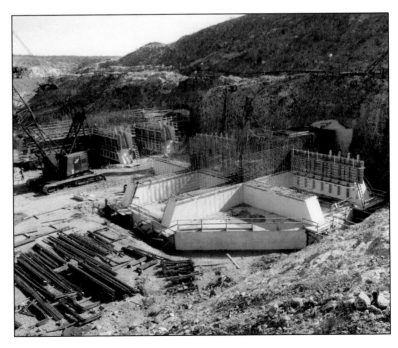

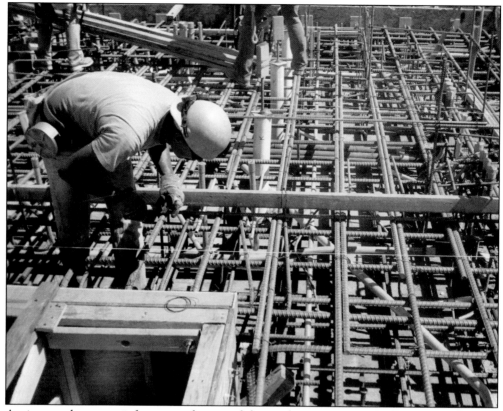

An iron worker sets reinforcement for one of the intake towers in 1991. There were a host of contractors and subcontractors working on the New Waddell Dam. Since no exact records were kept on the total number of individuals who worked on the project, it is difficult to say how many there actually were. About 300 contract workers worked on the main dam site. (Courtesy of the U.S. Bureau of Reclamation.)

In 1992, three construction workers perched high above the river perform work on the gantry crane that was installed to service the intake towers. While job site safety and awareness had come a long way since the raising of the Old Waddell Dam, the work was still dangerous. One iron worker died during construction of the pump/generator plant when guy-wires failed to keep rebar mats separated. (Courtesy of the U.S. Bureau of Reclamation.)

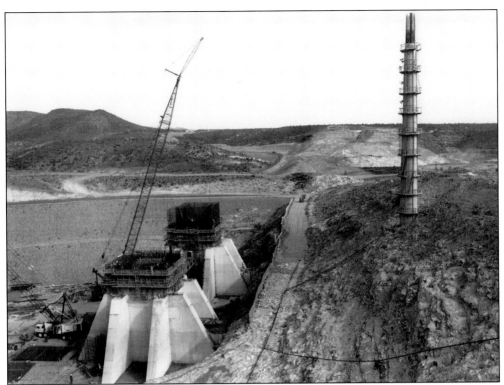

Work on the towers progressed through 1991. The view above is looking east from the west abutment. Like the Old Waddell Dam, large concrete structures on the new dam were poured in stages. Below, the towers are seen at nearly full length, a view that will not likely be seen again as the water level rises nearly to the tops of the structures. The thin spires will support a roadway extending from the crest of the dam over the lake to the towers. (Both, courtesy of the U.S. Bureau of Reclamation.)

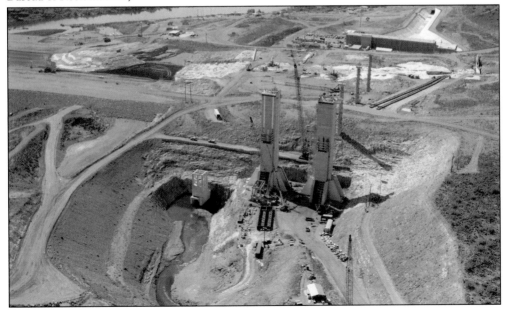

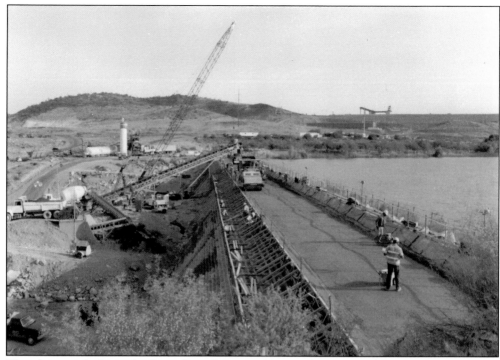

This photograph shows the Camp Dyer Diversion Dam undergoing modification in 1992. It was one of the Department of Reclamation's first applications of RCC (roller compacted concrete), a drier, more economical form of concrete. The modified dam has a crest length of 872 feet, and the height was raised to 79 feet. The lower lake water surface is 1,447 feet, about one-third smaller than it was. (Courtesy of Maricopa Water District.)

Lower Lake Pleasant was renamed Hank Raymond Lake after the MWD president (left) responsible for the agreement allowing the breach of the Old Waddell Dam while maintaining the MWD as a private enterprise on the lake. It owns and operates the Camp Dyer Diversion Dam and Hank Raymond Lake, retains 225 acres of land, and retains ownership of 157,600 acre-feet of water at Lake Pleasant. (Courtesy of Maricopa Water District.)

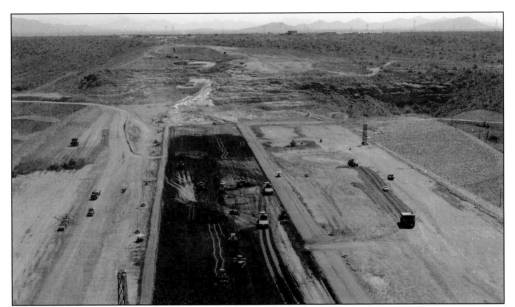

This photograph, taken in 1991, shows heavy machinery placing and compacting the dense clay core of the New Waddell Dam. The clay forms a barrier that is impervious to water. The light-colored areas bracketing the core will be filled with materials consisting of sand, gravel, and soil, forming a base width (at center) of over 1,200 feet. (Courtesy of the U.S. Bureau of Reclamation.)

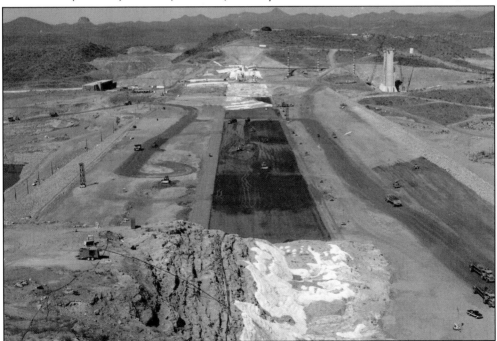

This view was taken from the east abutment, showing the dam interior while under construction in 1991. The intake towers and roadway supports can be seen at top right. The white material being applied on the abutments is a grout applied under pressure and capped over to seal fractures in the rock foundation. It could be described as a kind of "root canal" for rock. (Courtesy of the U.S. Bureau of Reclamation.)

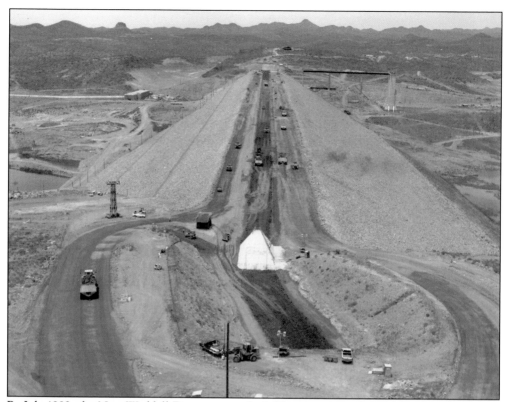

By July 1992, the New Waddell Dam starts to look like a massive, elongated pyramid rising up from the riverbed. Seen from the east abutment (above), the outer zones are in place, pressing down on the core from both sides. The downstream face is covered with large boulders or "riprap," the towers are nearly complete, and the service roadway is in place but for one segment. Below is an upstream view showing the space between the old and new dams, which must be filled in with water before the final phases of construction can take place. (Both, courtesy of the U.S. Bureau of Reclamation.)

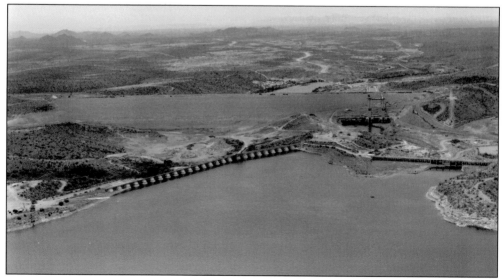

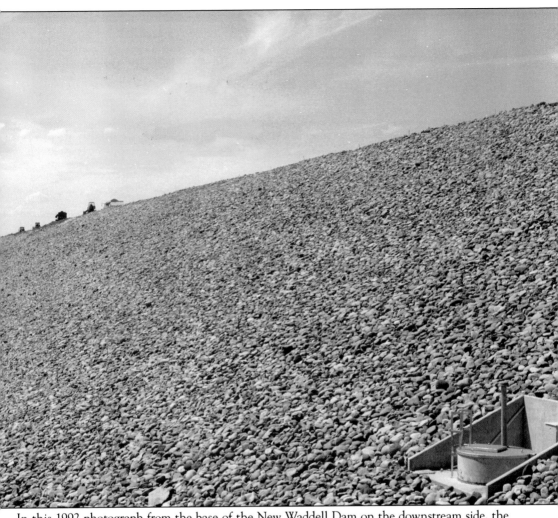

In this 1992 photograph from the base of the New Waddell Dam on the downstream side, the enormous scale of the project can be appreciated. The heavy equipment working about 30 stories above, at the dam crest (top left), looks like ants. More than 16 million cubic yards of material were used. (Courtesy of the U.S. Bureau of Reclamation.)

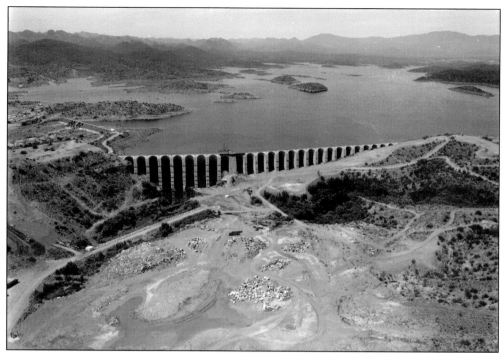

By September 1992, the area between the dams is ready for infilling with water. Some scaffolding can be seen on the dam just above the penstock outlet (above). As if in a last gasp at life, the butterfly valve on the river outlet refused to budge and a crew had to coax it open. After some initial difficulties, the old Lake Pleasant gives way to the new (below) as the inundation begins. (Both, courtesy of the U.S. Bureau of Reclamation.)

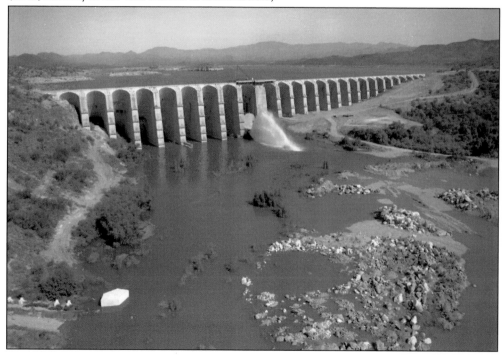

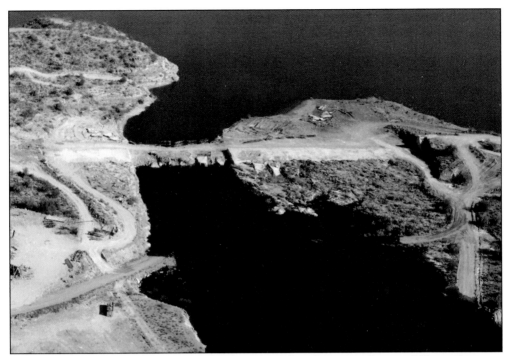

Some of the Old Waddell Dam needed to be removed as the entire dam would be underwater, presenting a hazard for boaters, particularly at low water levels. In October 1992, the old spillway was removed, leaving a scar that will be covered over by the rising waters. (Courtesy of the U.S. Bureau of Reclamation.)

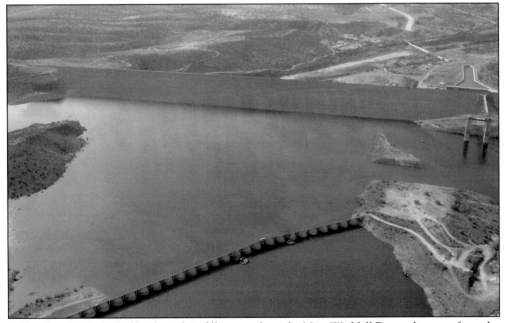

In October 1992, the half-mile-wide infill is complete; the New Waddell Dam takes over from the Old Waddell Dam. It will withstand the force exerted by 1,108,600 acre-feet of water at maximum elevation. (Courtesy of the U.S. Bureau of Reclamation.)

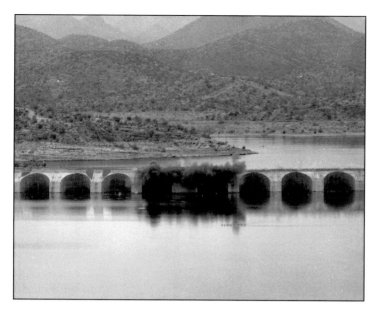

Demolition work to remove the steel roadway, added in 1935, took place on the Old Waddell Dam in October 1992. Rather than taking down the entire dam, it was only necessary to make a breach through it in order to allow safe access to the main boat ramp, to the MWD's Pleasant Harbor, near the east side of the new dam, and to keep water levels consistent. (Courtesy of the U.S. Bureau of Reclamation.)

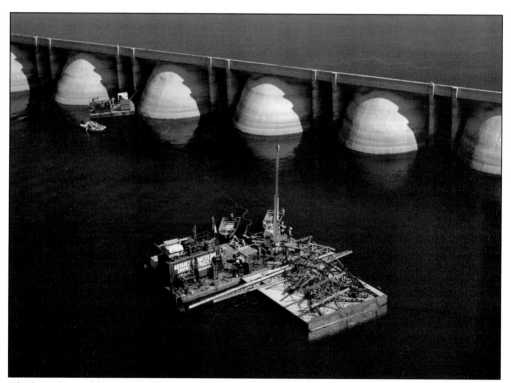

The breach would be 224 feet long and 70 feet deep; rather than placing explosives, it was decided that the job would be done by cutting through the barrel arches. The task fell to subcontractor Advance American Diving Services, Inc. In this photograph from October 1992, they can be seen positioning their equipment on barges along the arches. (Courtesy of the U.S. Bureau of Reclamation.)

The contraption seen here in October 1992 is actually a giant diamond-tipped wire saw. It was positioned along the four arches that were to be removed both above and, by divers, underwater. The various sprockets control tension and position the wire. (Courtesy of the U.S. Bureau of Reclamation.)

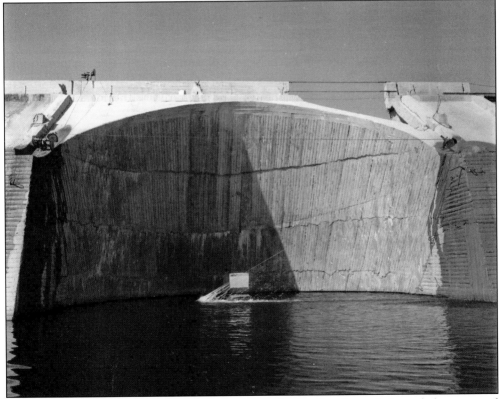

In November 1992, a rooster tail of water flies up as the saw does its work. Large bolts were used to keep the arches in place during cutting. They would be released by explosive charges in order to have them fall safely away. (Courtesy of the U.S. Bureau of Reclamation.)

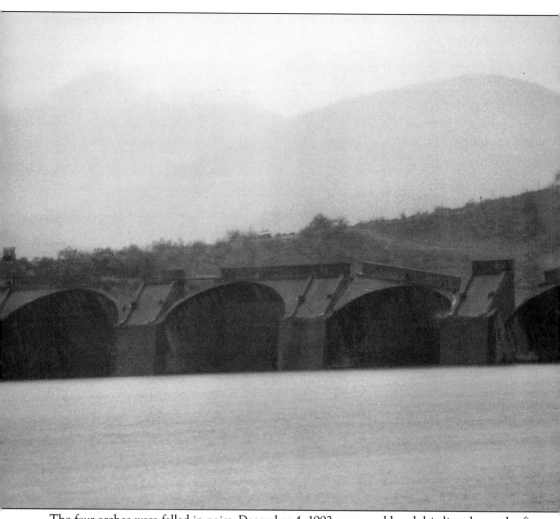

The four arches were felled in pairs. December 4, 1992, was a cold and drizzling day as the first two sections begin to tumble down, seen here from the downstream side. (Courtesy of the U.S. Bureau of Reclamation.)

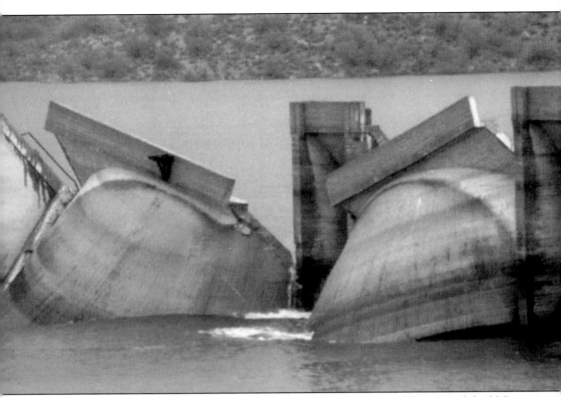

The same arches are falling, seen from the upstream side moments later. (Courtesy of the U.S. Bureau of Reclamation.)

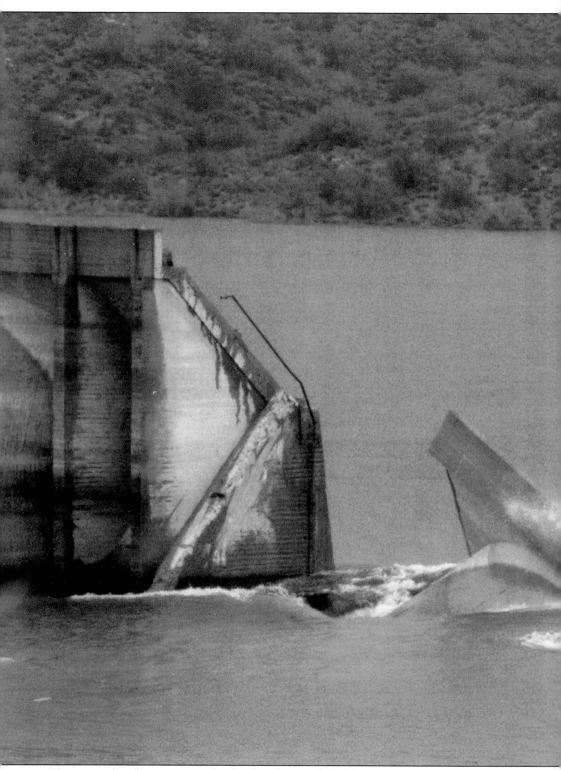

The two arches disappear into the depths of a new Lake Pleasant, creating a tremendous wave

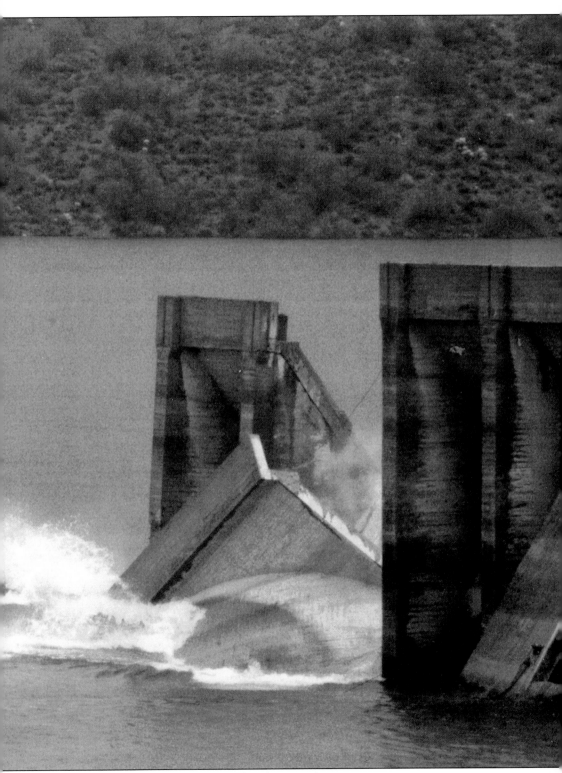

as they go. (Courtesy of the U.S. Bureau of Reclamation.)

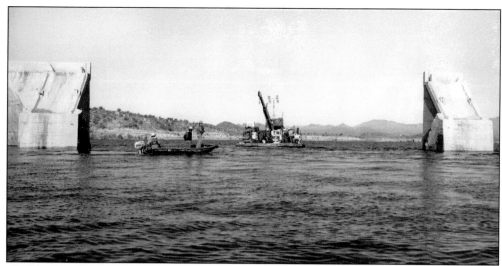

The breach is photographed in December 1992, just days after being completed. Unlike a natural lake, the artificial lake's water level can drop by as much as 125 feet. Normally the Old Waddell Dam sleeps quietly underwater, a favorite spot for divers when it's not too deep and a fish attractant, making it a popular fishing spot. Boats pass safely through the gap at low water. (Courtesy of the U.S. Bureau of Reclamation.)

In 1994, as Lake Pleasant fills to its new high water level, the old shoreline disappears, taking along with it the old infrastructure like roads and boat ramps. (Courtesy of the U.S. Bureau of Reclamation.)

Here in 1992, the new spillway for Lake Pleasant is under construction. It actually consists of two spillways. The first has an elevation of 1,706.5 feet and is rated at 187,000 cubic feet per second; the second has an elevation of 1,725 feet and is rated 129,000 cubic feet per second. In case of a large release, South Park Road (bottom) would be washed away. (Courtesy of the U.S. Bureau of Reclamation.)

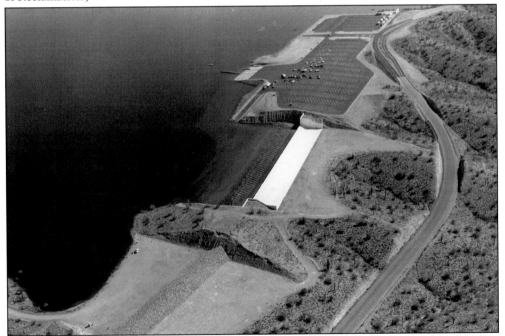

In 1994, Lake Pleasant approaches the spillways. There are no spillway control gates. The first spillway (center) uses a concrete ramp to channel water into the Morgan City Wash, which feeds into the Agua Fria River. The second (lower left) is a "fused plug" spillway. As water overtops its cobble embankment, it erodes away, allowing a substantial water release to prevent the dam from overtopping. (Courtesy of the U.S. Bureau of Reclamation.)

The dam's cornerstone reads, "New Waddell Dam, dedicated October 29, 1992, a working testimony to successful partnering of the Bureau of Reclamation (BOR) and Ebasco." From left to right are Bob Towels (BOR), Bill Fraser (BOR), Bob Johnson (BOR), Vern Bloom (Ebasco), Bob Marshall (Ebasco), Dave Huss (BOR), Dennis Schroeder (BOR), Congressman John Rhodes, John Sayer (Ebasco), Robert Zaist (Ebasco), Denis Underwood (Ebasco), and Dave Paul (principal engineer). (Courtesy of the U.S. Bureau of Reclamation.)

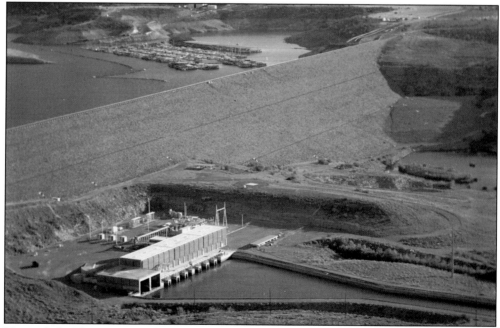

Here is Lake Pleasant around 1994. The New Waddell Dam draws a line of contrast between the artificial world of Lake Pleasant, with Pleasant Harbor Marina floating about 200 feet above the natural desert just beyond the downstream face of the dam. (Courtesy of the Central Arizona Project.)

## Seven

# THE GOOD, THE BAD, AND THE UGLY

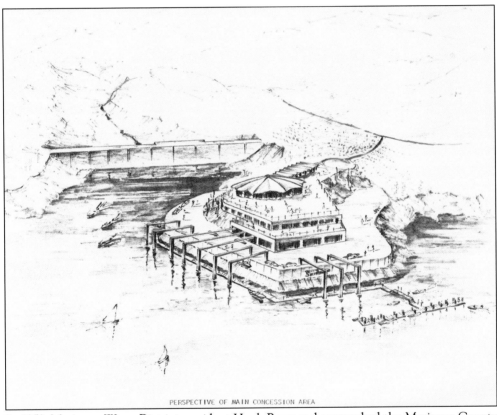

PERSPECTIVE OF MAIN CONCESSION AREA

In 1959, Maricopa Water District president Hank Raymond approached the Maricopa County Board of Supervisors with the idea of locating a county park around Lake Pleasant. Though rejected at first, the idea was finally accepted. Maricopa County Parks Department acquired 5,700 acres around Lake Pleasant, which included 2,150 acres of the lake itself, including Lower Lake Pleasant. In 1960, the Maricopa County Parks and Recreation Commission proposed an ambitious plan for a park that would accommodate 40,000 visitors at a time. Included were trails and facilities for 300 horses, parking for 10,000 automobiles and 5,400 boat trailers, wet slips for 4,420 boats, youth camps, and more. This illustration, from 1960, shows the palatial proposed main concession area. The park facilities surrounding the old lake were far smaller and less elaborate. (Courtesy of Phoenix Public Library.)

Lake Pleasant Lodge, here around 1984, started as a bait shop sometime after the completion of the Old Waddell Dam and was turned into a lodge to compete with the nearby Castle Hot Springs Resort. It served as headquarters of the Lake Pleasant Regional Park, eventually becoming a youth camp. It served in that capacity until the 1980s, when it was demolished. (Courtesy of the Lake Pleasant Regional Park.)

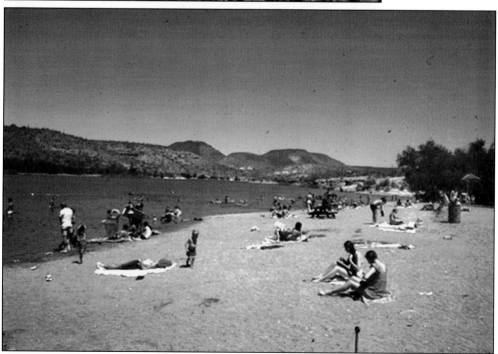

Lower Lake Pleasant Beach was developed by the Maricopa County Parks Department. Sand was laid on the shore of the lower lake, which became one of the more popular recreational spots in the park. (Courtesy of the Lake Pleasant Regional Park.)

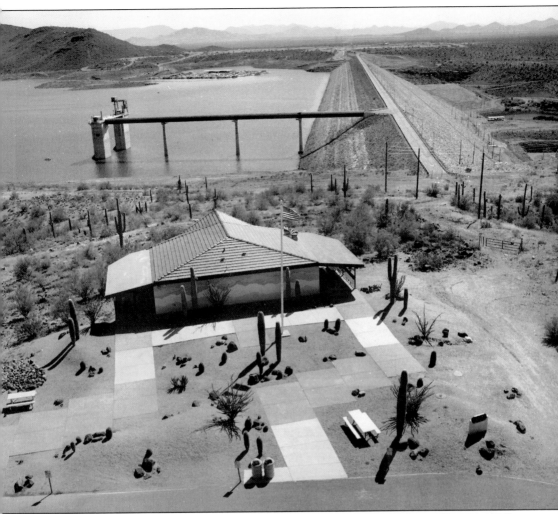

Overlooking New Waddell Dam from the west, the Lake Pleasant Visitor's Center (here in 1995) was built by the Bureau of Reclamation. It is the primary information center for Lake Pleasant Regional Park. Park lands are owned by the U.S. Bureau of Reclamation and the Bureau of Land Management. In 1990, the Maricopa County Recreation Service Department entered an agreement as managing agency for the land. The park around the new lake (completed in 1993), while much enlarged and improved, still did not measure up to the vision of the 1960 Proposed Master Plan. As of 2009, Lake Pleasant Regional Park averaged 600,000 visitors annually and had grown to 23,662 acres featuring 148 developed or semi-developed campsites, a 10-lane boat ramp that can accommodate 417 vehicles with trailers, and a four-lane ramp that can hold 133 more. Two privately run marinas—Pleasant Harbor Marina and Scorpion Bay Marina—can accommodate several hundred boats of all sizes, including houseboats, where some people live year-round. (Courtesy of the U.S. Bureau of Reclamation.)

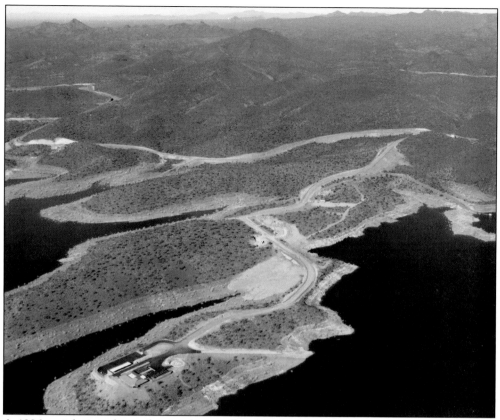

A 1996 aerial view shows the nearly completed Park Operations Center, headquarters and administration center for Lake Pleasant and the nerve center for the park. It includes its own boat ramp, docks, and heliport for rapid response to emergencies. (Courtesy of the U.S. Bureau of Reclamation.)

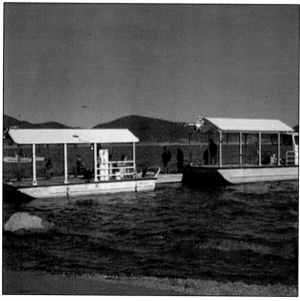

The Navigation Aid boats are on duty laying marker buoys on Lake Pleasant around 2005. Maricopa County Parks Department employs a full-time crew to keep up with marking hazards on the constantly rising and falling reservoir. (Courtesy of Lake Pleasant Regional Park.)

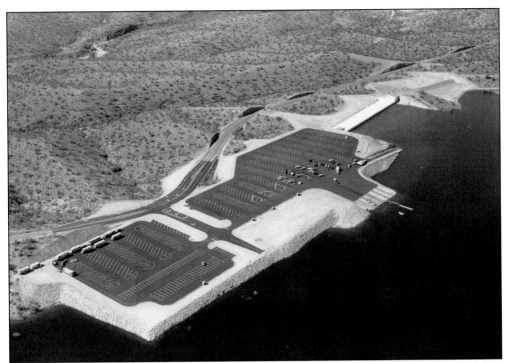

Above is the main 10-lane boat ramp for Lake Pleasant Regional Park around 1994. It can accommodate hundreds of boaters and remain functional with water levels 100 feet below maximum elevation. Below, construction personnel survey a curious feature of the 10-lane ramp. They are standing on the lower spillway looking out over overflow boat trailer parking spaces that are located directly behind the spillway. When the water level is high, the parking area is underwater. (Both, courtesy of the U.S. Bureau of Reclamation.)

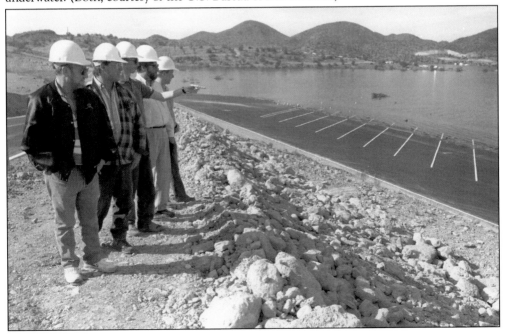

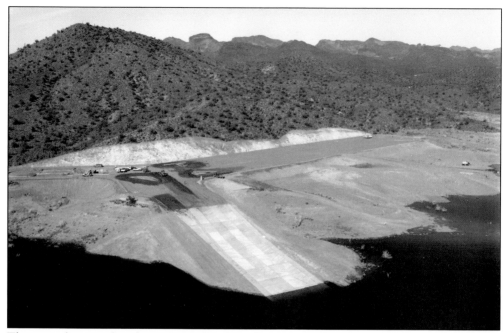

These are photographs taken in 1996 that show the four-lane North Ramp under construction. It is located on the Castle Hot Springs arm of the lake and, like the 10-lane boat ramp, is designed to be functional at 100 feet below maximum elevation. Below, the ramp and parking area can be seen with the Castle Hot Springs Road snaking through the desert above. (Both, courtesy of the U.S. Bureau of Reclamation.)

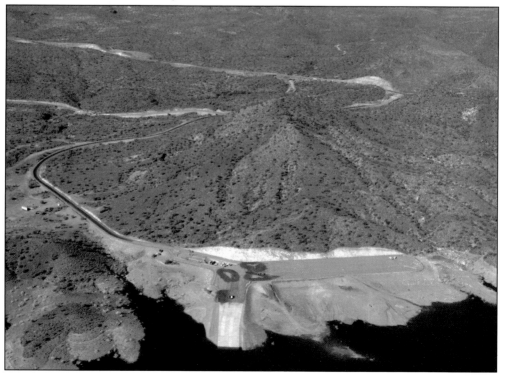

Pleasant Harbor, next to the east abutment of the dam, is shown here under construction in 1995. The marina and wet slips are completed, as is the private boat ramp. Still under construction (upper left) are the RV resort and the dry storage for boats. The marina is designed to operate with water levels a low as 125 feet below maximum elevation. (Courtesy of the U.S. Bureau of Reclamation.)

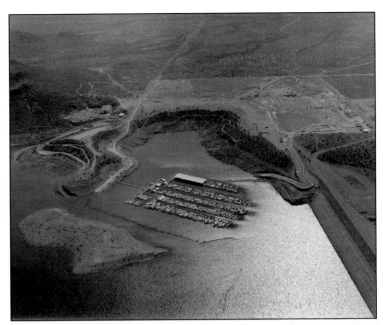

Scorpion Bay Marina is pictured shortly after it opened in 2009. The $20-million, 146-acre facility was challenged by the company that operated the Pleasant Harbor Marina, claiming that the county's bidding process violated federal law. It was also challenged by fishermen fearing the new marina would cause overcrowding on the lake, adversely affecting fishing. Its 2008 opening was delayed over permit issues until 2009. (Author's collection.)

A wind surfer takes advantage of one of Lake Pleasant's more agitated states in 2007. Native brittlebush (*Encelia farinosa*) is blooming along the shore. Surrounded by desert landscape, on days when wave action makes it hazardous for small boats, it is easy to forget that this environment is as much a force of man as a force of nature. (Courtesy of Lake Pleasant Regional Park, photograph by Frank H. Meyerholtz.)

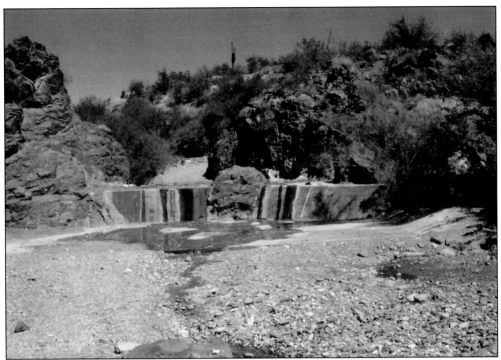

Damming the Agua Fria devastated native fishes. The Gila mountain sucker, Gila chub, Gila topminnow, and speckled dace disappeared from Lake Pleasant, though some survived in streams above the lake. This fish barrier (above), placed on Tule Creek (which empties into Lake Pleasant) in 1996, holds surviving Gila topminnows (below) in, while keeping non-native species out. This fish holds special interest to scientists who study its adaptive resistance to skin cancer. (Above, courtesy of the U.S. Bureau of Reclamation; below, courtesy of U.S. Fish and Wildlife Service, photograph by Marty Jakle.)

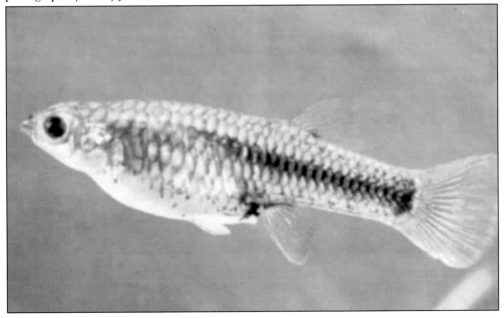

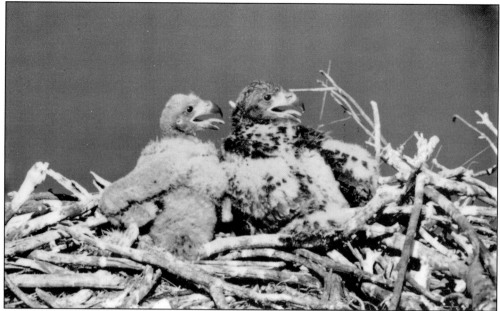

Bald eagles nest along Lake Pleasant around 2006. In 1978, the bald eagle was designated an endangered species. An attempt at recovery included creating enclosures, allowing them to breed absent of any human presence. Arizona had 21 enclosures. On Lake Pleasant, the enclosure extends from the opening of the Agua Fria Arm on the northeast side of the lake north to about Indian Mesa. The area is closed to entry by watercraft, vehicle, foot, even aircraft (below 2,000 feet) from mid-December through mid-June each year. There have been three nests in the area, which have recorded over 20 hatchings, making it the most prolific and diverse enclosure in the state. The bald eagle was removed from the endangered species list in 2007. The Agua Fria enclosure remained active to ensure the eagles' continued success. (Both, courtesy of Lake Pleasant Regional Park.)

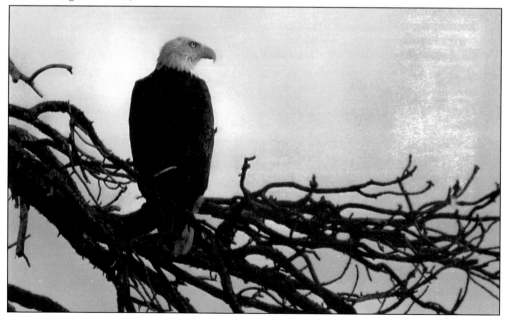

Salt cedar (*Tamarix ramosissima*), a native of Asia, was introduced into the United States in the early 1800s. It was used along the Colorado River in an attempt to control erosion. It grows best in moist sandy soils and thrives around Lake Pleasant. Extremely invasive and a rapid grower, it readily replaced native species like cottonwood trees and has dramatically changed the look of the landscapes wherever it occurs. (Author's collection.)

Bermuda grass (*Cynodon dactylon*), native to Africa, has been in Arizona for over 100 years. This photograph was taken on the Agua Fria River bed, near the Boulder Creek Ranch. It grows in many of the stream beds and washes in the park and can even be seen on the shores of Lake Pleasant. It has been adopted as a food source by grazing animals. (Author's collection.)

The Arizona fan palm (*Washingtonia filifera*) is the only palm native to Arizona. It occurs naturally on Castle Creek, a tributary of the Agua Fria. However, this location is well upstream. Located on the Boulder Creek Ranch site, it may have grown from a seed, as there are specimens, obviously planted, growing nearby on the site of one of the buildings there. (Author's collection.)

The giant saguaro (*Cereus giganteus*), a magnificent park specimen, grows skyward around 2004. An icon of the West, its range is actually limited to the Sonoran Desert. It is doubtful any attempt was made to save them during construction of the old dam. Salvage attempts were made when the new dam was built; however, it was not always practical. Many drowned in the rising waters. (Courtesy of Lake Pleasant Regional Park.)

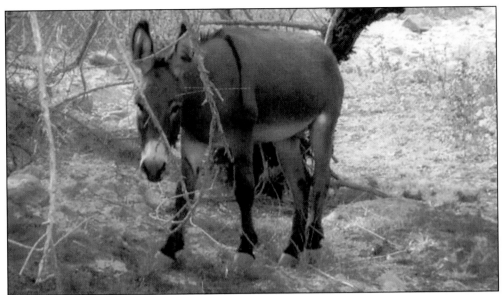

Wild burros (*Equus asinus*), native to Africa, may be the park's most beloved creatures. Though they were introduced earlier by the Spanish, the population around Lake Pleasant descended from stock introduced during the 1800s. They compete with native species such as mule deer. Some favored eradication; others advocated protection. They are protected under the Wild Free-Roaming Horse and Burro Act of 1971. (Courtesy of Lake Pleasant Regional Park, photograph by Frank H. Meyerholtz.)

A park native, the cougar or mountain lion (*Puma concolor*) escapes the midday sun. Remarkably adaptable, it is just as much at home in the desert as it would be in a pine forest. Cougars can weigh up to 160 pounds and can make jumps of up to 40 feet. It is one of the few antagonists the wild burros face. (Courtesy of Lake Pleasant Regional Park.)

The first recorded stocking of non-native fish in Lake Pleasant was January 8, 1941, by the Arizona Game and Fish Department. The channel catfish (*Ictalurus punctatus*), a popular game fish, was selected. Their native habitat is from Canada to Mexico, west of the Rockies. Their hardiness, exceptional sense of taste and smell, and their propensity to scavenge for food render them highly adaptive. (Courtesy of U.S. Fish and Wildlife Service.)

Also among the first non-native fishes were largemouth bass (*Micropterus salmoides*), introduced in April 1941. They represent the glamour game fish of the professional fishing circuit. Not true bass, they are actually members of the sunfish family native to the Central and Southeastern United States. Largemouth tournaments are regularly held on the lake. Professional and amateur anglers compete for big purses. (Courtesy of Lake Pleasant Regional Park, photograph by Frank H. Meyerholtz.)

The bluegill (*Lepomis macrochirus*), a member of the sunfish family and native to a wide portion of North America, was also an early introductee to the lake in April 1941. A popular pan fish and easy to catch, its name derives from the bright-blue edging near the gills. (Courtesy of Lake Pleasant Regional Park, photograph by Frank H. Meyerholtz.)

Black crappie (*Pomoxis nigromaculatus*), a relative latecomer to Lake Pleasant, was introduced in 1965 and is also a member of the sunfish family. They are extremely popular game fish, particularly during the spring spawn, as is their close relative the white crappie, for which the lake set a state record (3 pounds, 5.28 ounces) in 1982. (Courtesy of Lake Pleasant Regional Park, photograph by Frank H. Meyerholtz.)

Striped bass (*Morone saxatilis*) are invaders from the Colorado River, which was pumped in during the early 1990s. Native of the Atlantic coastline, they can survive in salt or fresh water. Their presence in Lake Pleasant is alarming to tournament fisherman as they are believed to crowd largemouth bass out. Lake Pleasant set a state record (27.28 pounds) in 2007. (Courtesy of Lake Pleasant Regional Park, photograph by Frank H. Meyerholtz.)

White bass (*Morone chrysops*) were introduced to Lake Pleasant in 1965. Its native habitat is the tributaries of the Mississippi River. Sometimes confused with the striped bass, the two can be hybridized. The resulting breed is called sunshine bass. As of 2009, there have been no introductions of the hybrid in lake. No known natural hybrids have occurred. (Courtesy of Lake Pleasant Regional Park, photograph by Frank H. Meyerholtz.)

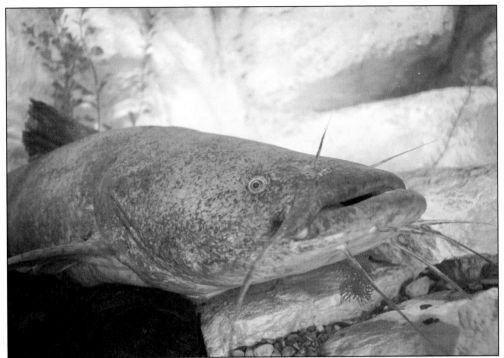

The year 1994 saw flathead catfish (*Pylodictis olivaris*) arrive as "uninvited guests" from the CAP. Unlike their scavenging cousins, the channel catfish, these brutes prefer live prey, such as bluegill. Native to the Mississippi and Missouri Rivers, they are the largest game fish currently inhabiting Arizona waters, reaching over 70 pounds. A tasty game fish, they are prized for both their fight and their flesh. (Courtesy of U.S. Fish and Wildlife Service.)

Quagga mussels (*Dreissena rostriformis bugensis*) are perhaps the lake's most alarming example of the law of unintended consequences. This thumbnail-sized, Ukrainian freshwater mollusk also arrived with the CAP. They are prolific breeders who multiply rapidly, clustering around anything they can attach themselves to, such as the sandal in this photograph. They clog water intakes, boat hulls, and motors and cause millions in damages. (Courtesy of the U.S. Bureau of Reclamation.)

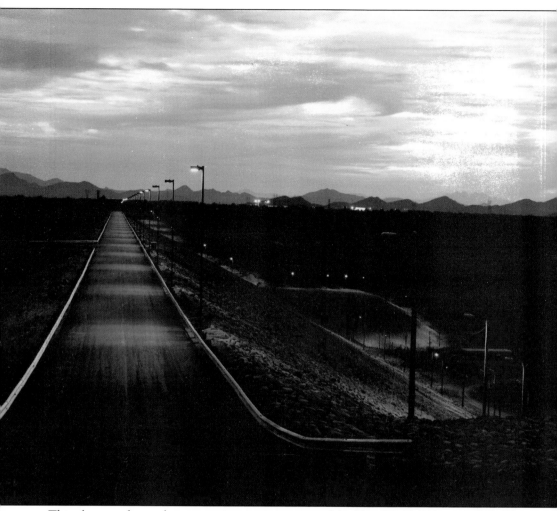

This photograph was shot on a quiet evening on top of the New Waddell Dam in 1993. Seen as part natural and part artificial, Lake Pleasant stands as a living monument to the symbiosis of humans and the Earth. From the time of the Hohokam until today, a struggle for balance and control plays out as people continue the quest to understand themselves, their world, and their place in it. (Courtesy of the U.S. Bureau of Reclamation.)

# BIBLIOGRAPHY

Cordes, Claire Champie. *Ranch Trails and Short Tales*. Mesa, AZ: Crown King Press, 1991.

Green, Margerie, ed. *Settlement, Subsistence, and Specialization in the Northern Periphery: The Waddell Project*. Tempe, AZ: Archaeological Consulting Services, Ltd., prepared for U.S. Bureau of Reclamation, 1989.

Introcaso, David M. Autumn. "The Politics of Technology: The Unpleasant Truth About Pleasant Dam." *Western Historical Quarterly*. 11 (3): 332–352.

———. *Waddell Dam and Maricopa County, Arizona: Photographs, Written Historical and Descriptive Data, Reduced Copies of Drawings*. San Francisco, CA: Historic American Building Survey, National Park Service, Western Region, Department of the Interior, 1988.

Robinson, Kim Stanley. *Red Mars*. New York, NY: Bantam Books, 1993.

Rogge, A. E., D. Lorne McWatters, and Melissa Keane. *The Historical Archaeology of Dam Construction Camps in Central Arizona*. Phoenix, AZ: Dames and Moore Intermountain Cultural Resource Services, prepared for U.S. Bureau of Reclamation, 1994.

Rogge, A. E., D. Lorne McWatters, Melissa Keane, and Richard P. Emanuel. *Raising Arizona's Dams: Daily Life, Danger, and Discrimination in the Dam Construction Camps of Central Arizona, 1890s–1940s*. Tucson, AZ: University of Arizona Press, 1995.

Solliday, Scott. *Homesteading and Ranching in the Vicinity of Lake Pleasant Regional Park, Maricopa and Yavapai Counties, Arizona*. Tempe, AZ: Archaeological Consulting Services, Ltd., prepared for U.S. Bureau of Reclamation, 2008.

*Waddell Dam*. Tempe, AZ: Salt River Project, 1987.

# DISCOVER THOUSANDS OF LOCAL HISTORY BOOKS FEATURING MILLIONS OF VINTAGE IMAGES

Arcadia Publishing, the leading local history publisher in the United States, is committed to making history accessible and meaningful through publishing books that celebrate and preserve the heritage of America's people and places.

## Find more books like this at
## www.arcadiapublishing.com

Search for your hometown history, your old stomping grounds, and even your favorite sports team.